Pete Davis
In Wildwood

For Rose

PETE DAVIS

IN
WILDWOOD

With an appreciation
by Conway Lloyd Morgan

Lars Müller Publishers

Acknowledgements
I am grateful for the generous support during the production
of this body of work from many individuals and institutions. Professor
Alistair Crawford, who has seen and encouraged this work
from the beginning. The School of Art, Media & Design at the
University of Wales, Newport, and my colleagues Ken Grant, Clive
Landen, Paul Reas, Helen Sear and Ian Walker at the European
Centre for Photographic Research, for their ongoing constructive
comments. Professor David Austin at the University of Wales,
Lampeter, for his interest and support for my work in Strata Florida.
Eve Ropek and Sophie Bennett at Aberystwyth Arts Centre for
instigating and organising the touring exhibition. Thanks also to
Geert Segers and Els Fieuw of the Karel de Grote-Hogeschool, and
Christoph Ruys of the Fotomuseum, Antwerp, for their help in
showing this work in Belgium, and to Lars Müller and Conway Lloyd
Morgan for making this book possible. Special thanks go, as
always, to my wife, Rose, for her constant help and support over
many years. P.D.

I shall be telling this with a sigh
Somewhere ages and ages hence:
Two roads diverged in a wood, and I –
I took the one less travelled by,
And that has made all the difference.
Robert Frost (1874–1963) from 'The Road Not Taken' 1920

Over the many years I have been photographing the landscape, I have sought to address many issues and ideas through numerous wide-ranging locations, and by photographing almost every kind of topographical feature. Woodland has always held a strange fascination for me and with this body of work, I have attempted to encapsulate many of those ideas by concentrating on this one motif.

Forests have always been an important aspect of the landscape, having both social and mystical significance. The history of the development of mankind can be plotted by the importance placed on trees and forests as a means of subsistence. The disappearance of large tracts of forest was one of the earliest consequences of prehistoric man acquiring even the most rudimentary stone tools. The transitions from Stone Age to Bronze Age to Iron Age and beyond, and later to the Middle Ages and the Industrial Revolution, saw the forests of Britain and Europe fluctuate in both size and importance. Legends, superstitions and rituals connected with woodlands and forests abound. It is hard to imagine any other feature or aspect of the land that has attracted to it such an historic collection of folklore.

The term 'wildwood' can sometimes evoke images of remoteness, danger and sinister beauty as typified by ancient contorted oaks, but the woodlands featured here owe their presence and visual appearance to centuries of management and human intervention. The ancient forests that still exist today do so thanks to a number of factors. Some are hardy, relatively untouched survivors of those that sprang up after the last period of glaciation some ten thousand years ago. Others, such as Pen Gelli, which features heavily in this book, still remain because the timber has been used for centuries for a variety of purposes, and the trees have been coppiced, allowing re-growth to preserve the useful harvest. It is highly likely that forests such as this have been in constant use since the Iron Age, where the timber was almost certainly employed in the early iron-making processes.

The forests of the Cistercian Abbey and farming settlements of Strata Florida were once intensively managed woodlands that have begun to 'revert to nature' in the centuries since the monks ceased

their occupation of the land. These woodlands, however, still contain traces of those early activities, and both the species present and their density and arrangement are due in part to the original planting and management. The proximity of these woods to an ancient important holy site imbues them with an atmosphere and presence that is almost tangible, and which one hopes is reflected in some way through these images.

The forests of Vermont, USA, are not 'ancient' in the accepted sense of the word, nor can they accurately be described as 'wildwood', unless one counts being inhabited by brown bear, moose and beaver as 'wild'. However, human intervention, as with other forests, has shaped the way they look and feel. Famed for the autumn hues so beloved of the 'leaf peepers' who flock to the state ever year to witness the colourful spectacle, the forests here owe their existence to more than pure nature. A hundred years ago Vermont was a relatively thinly forested state. Sheep farms prevailed and their management kept the trees at bay as grazing was prioritised over forestry. The economic decline in the sheep industry allowed land once intensively farmed to become covered with new saplings, and the ubiquitous sugar maple to flourish unhindered. Over time, a combination of this dense new growth, the contemporary exploitation of the sugar maple for its valuable sap, and wildlife activity has given these forests a unique aspect.

In this new collection, although concentrating on one motif, I have tried to encapsulate many of the elements of the wider landscape that have featured in my work over the years. Beauty, mystery, myth, spirituality and history are all represented here, all significant aspects of the landscape.

Pete Davis, Alltyblaca, Summer 2008

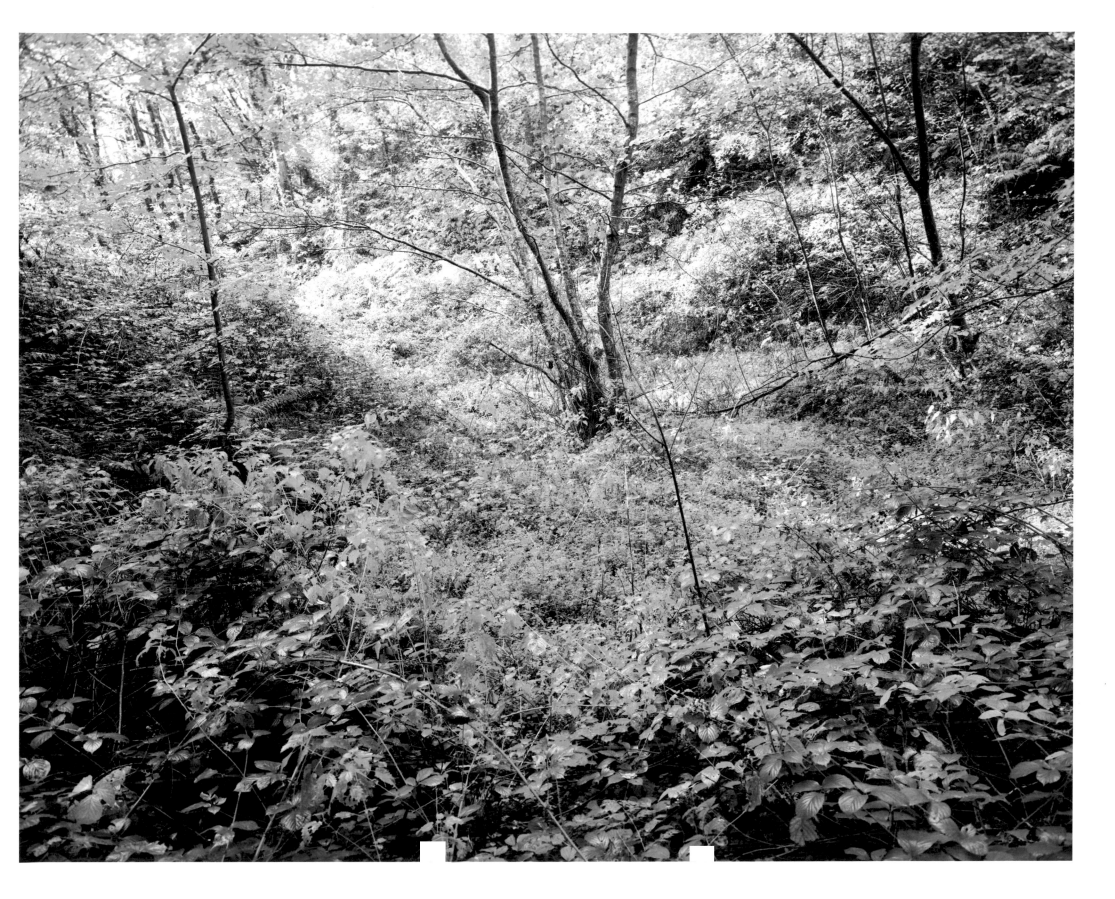

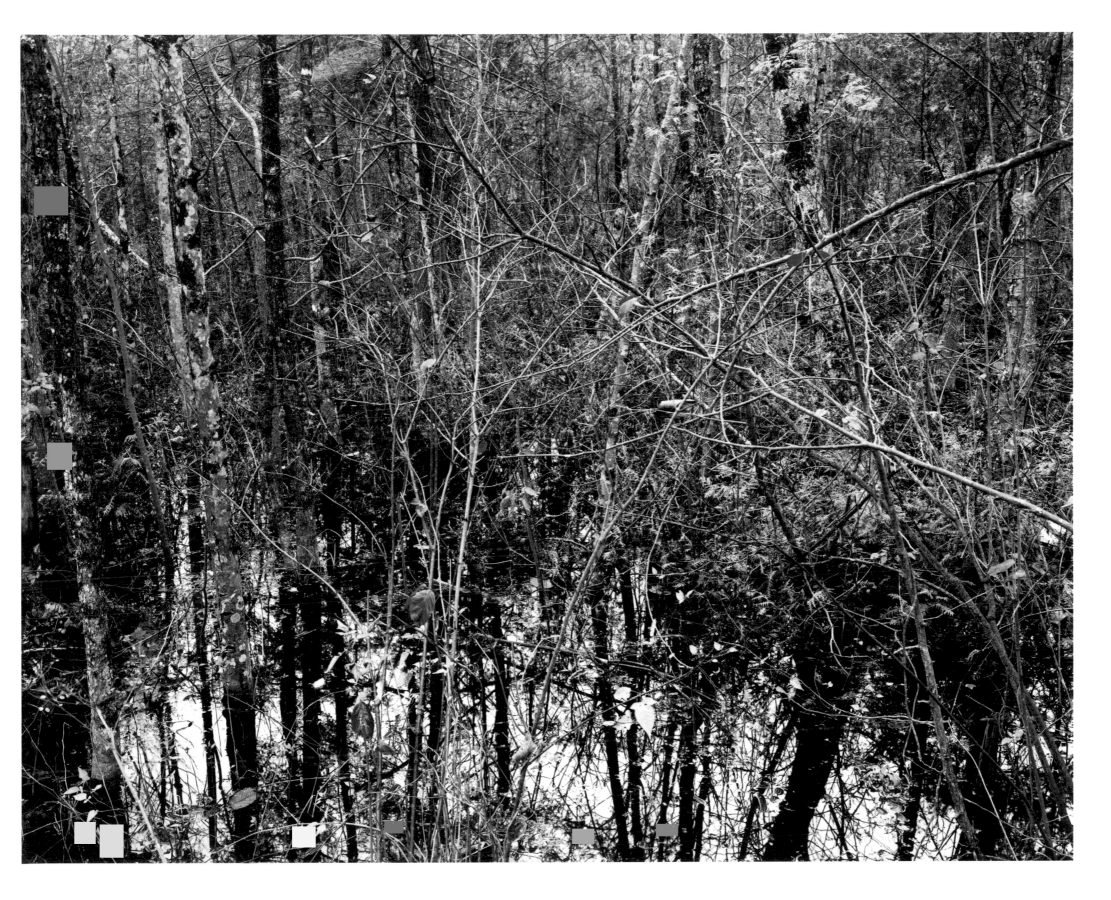

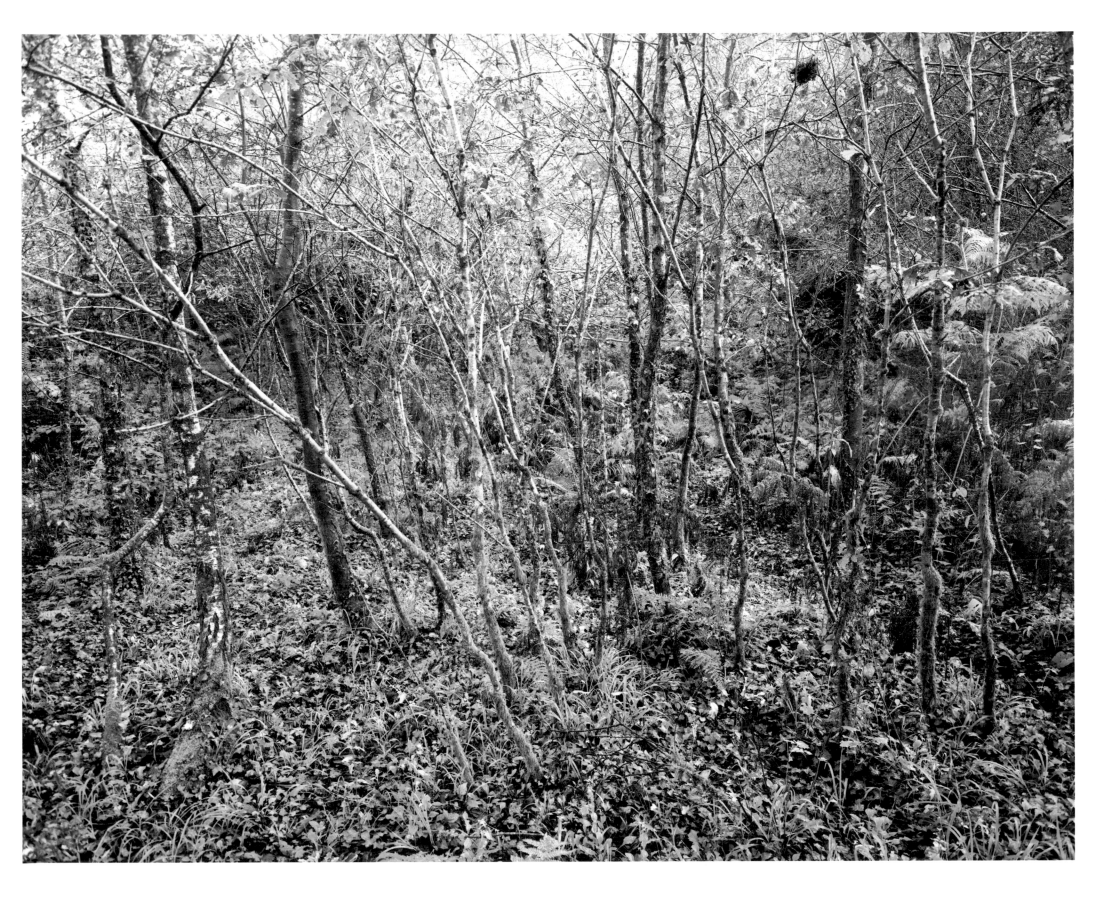

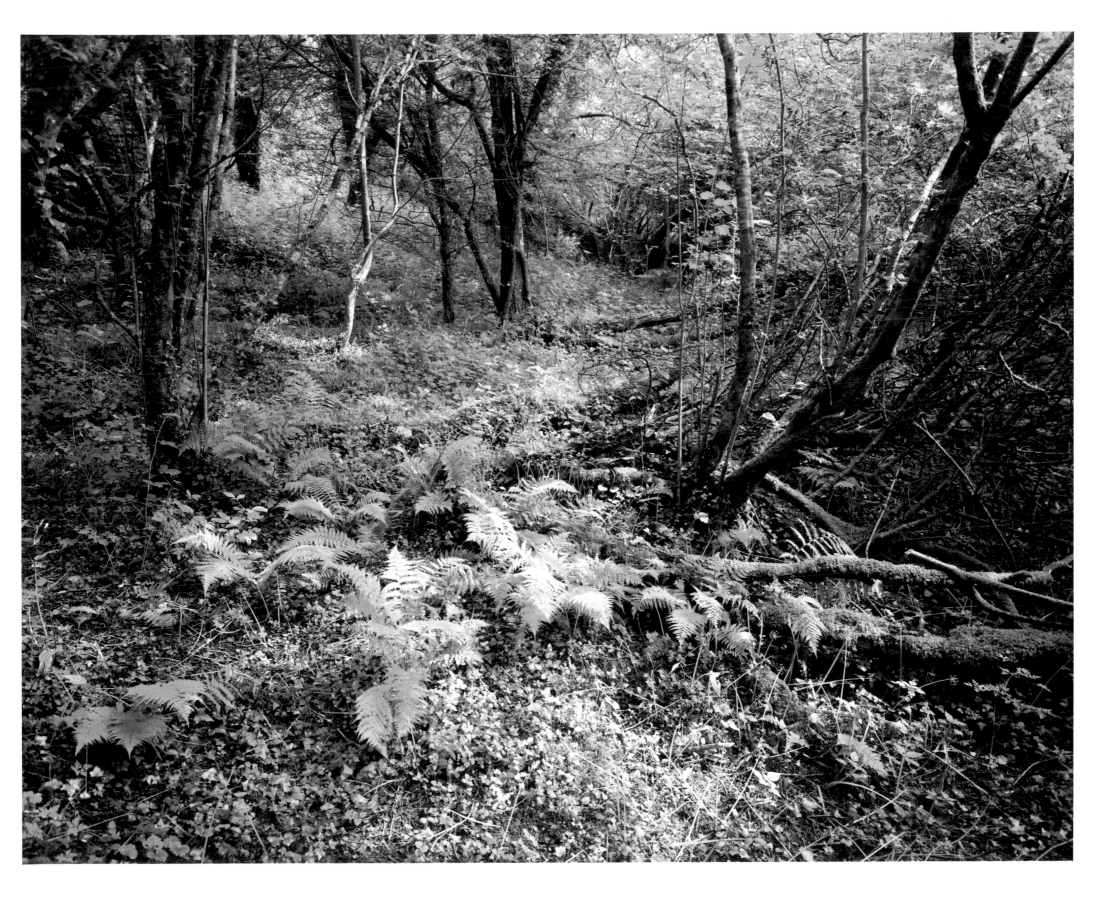

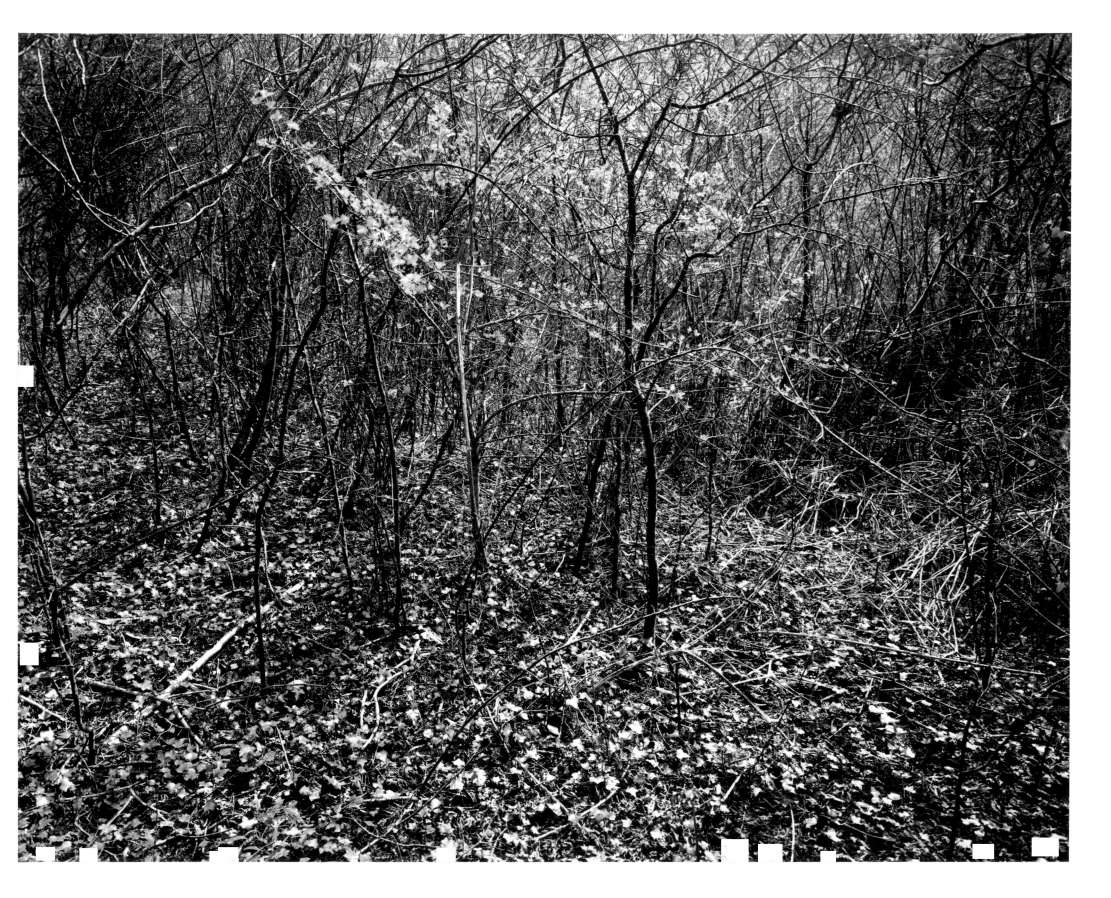

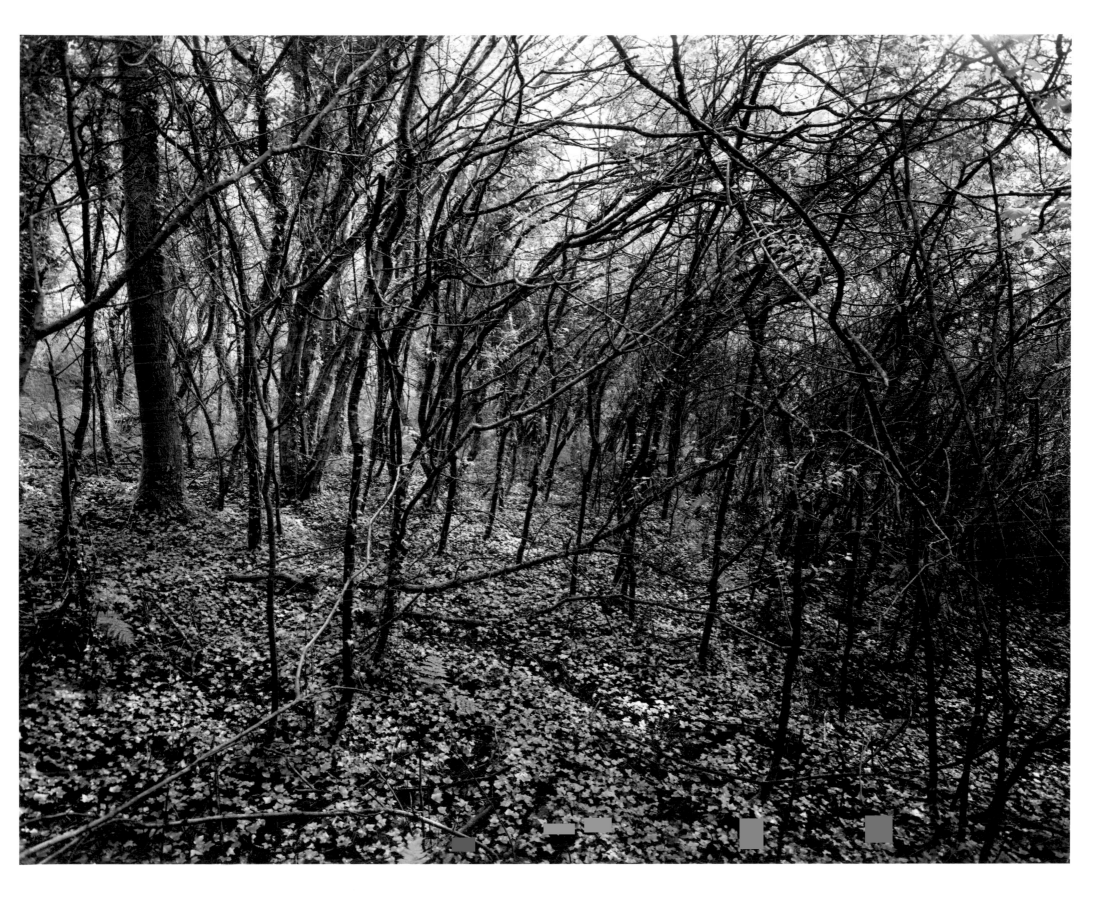

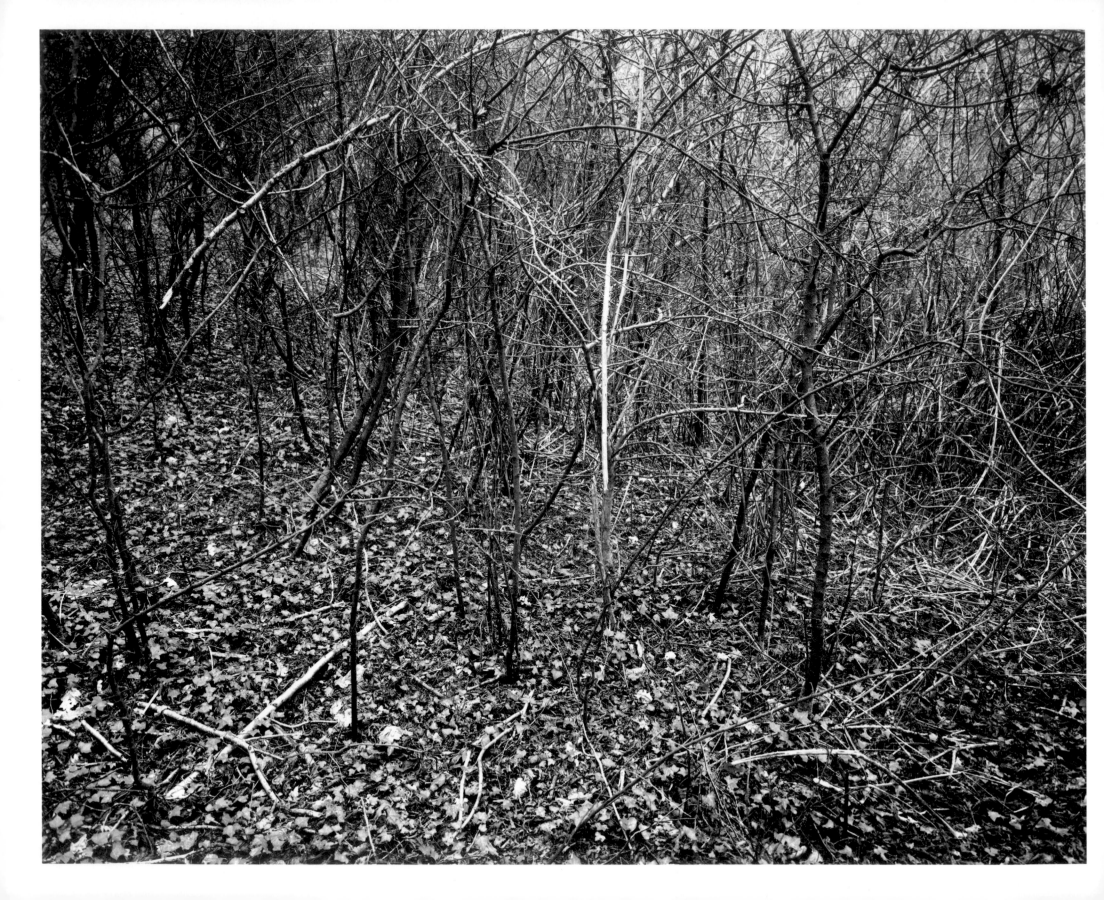

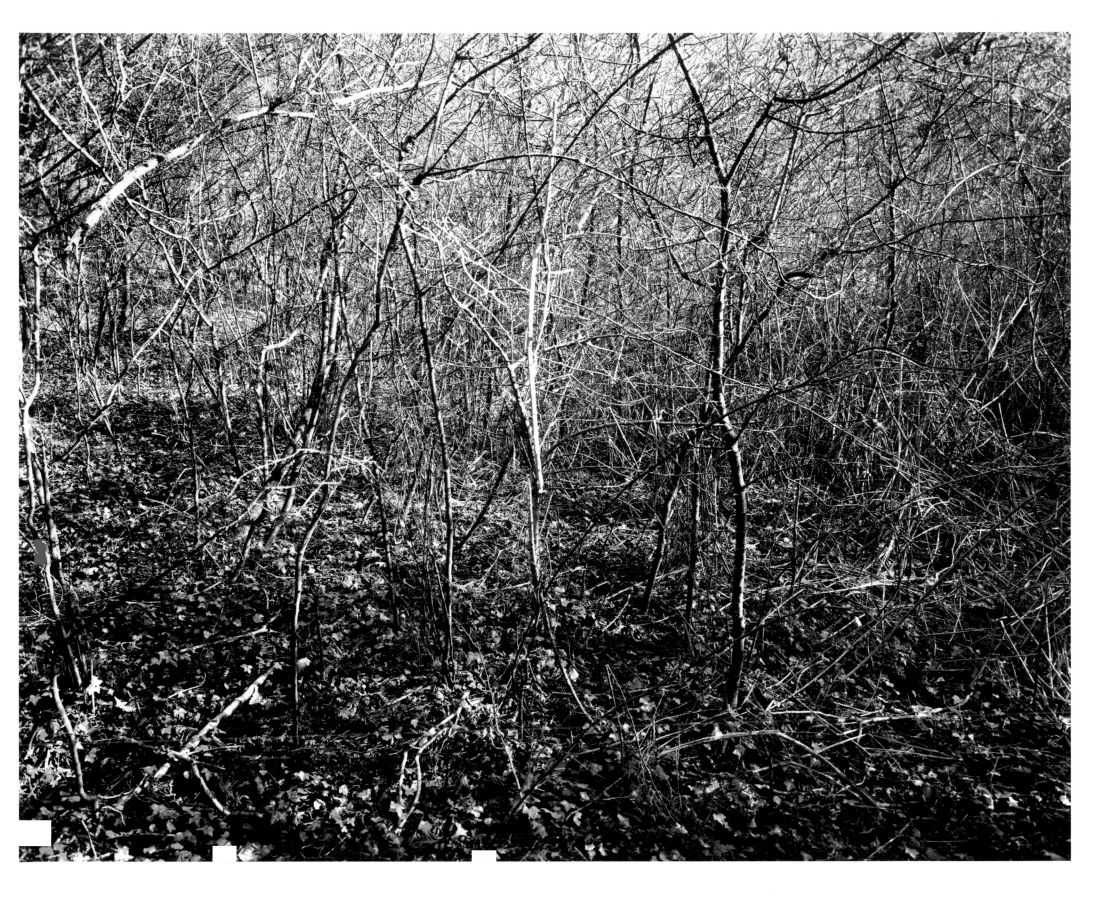

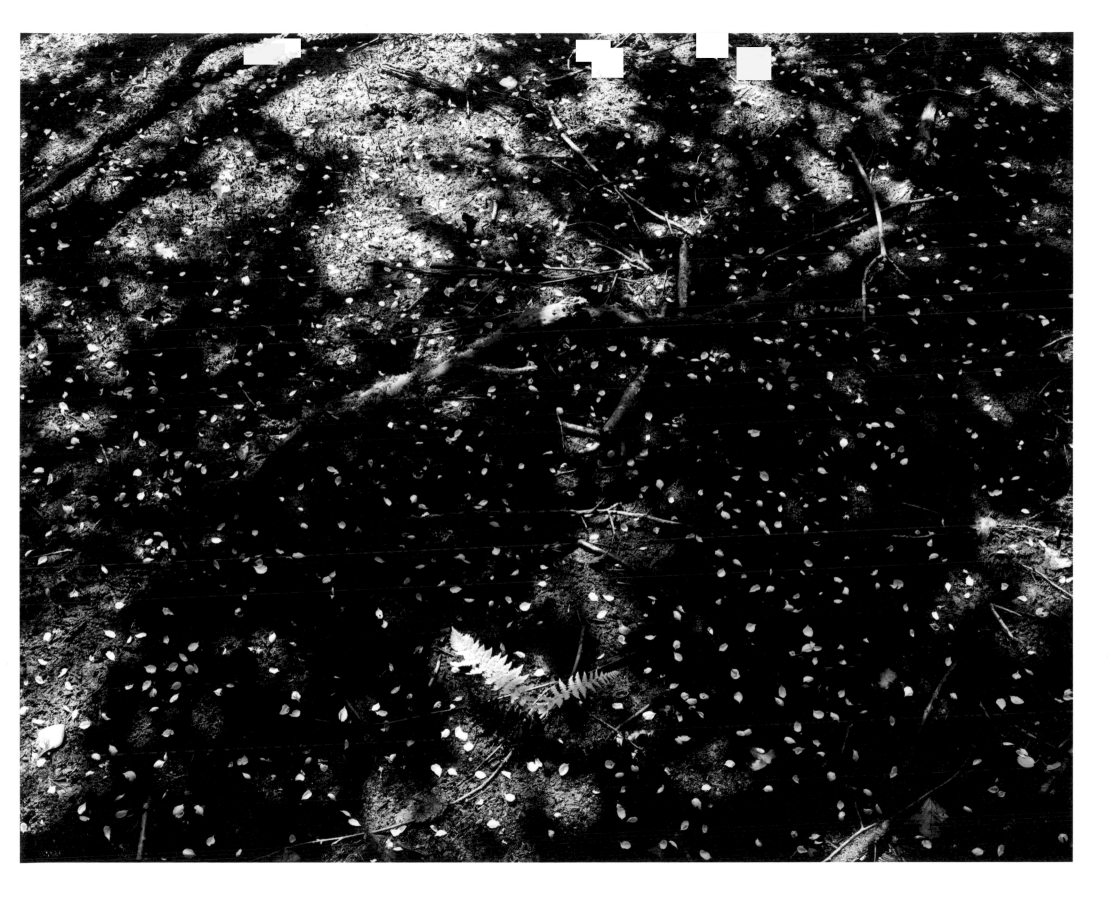

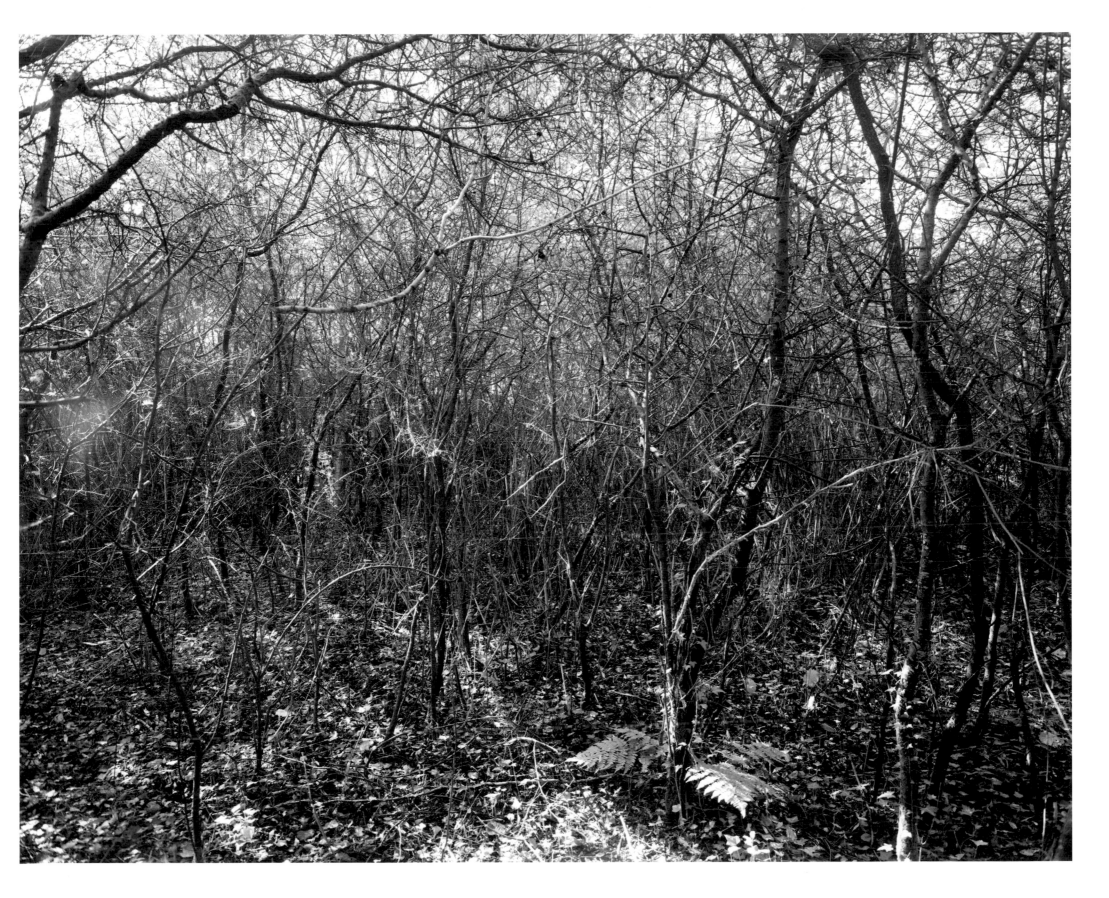

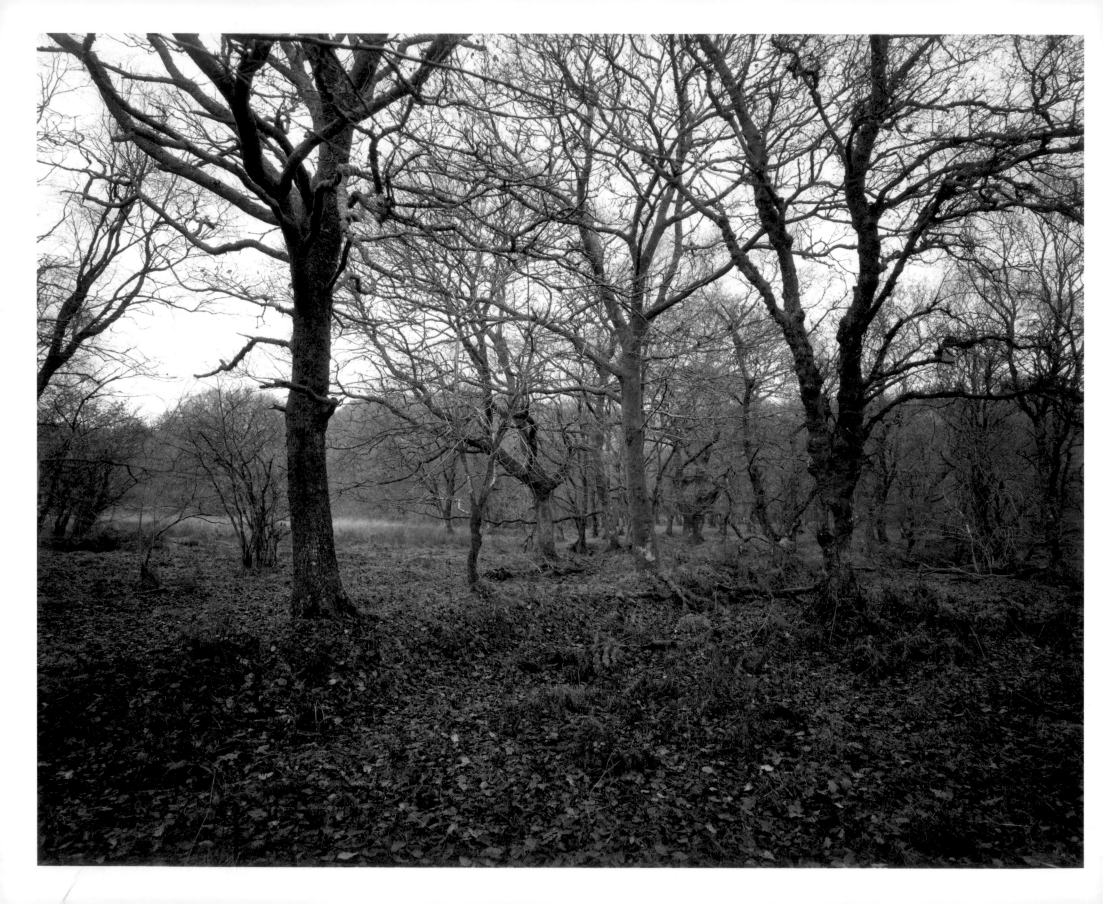

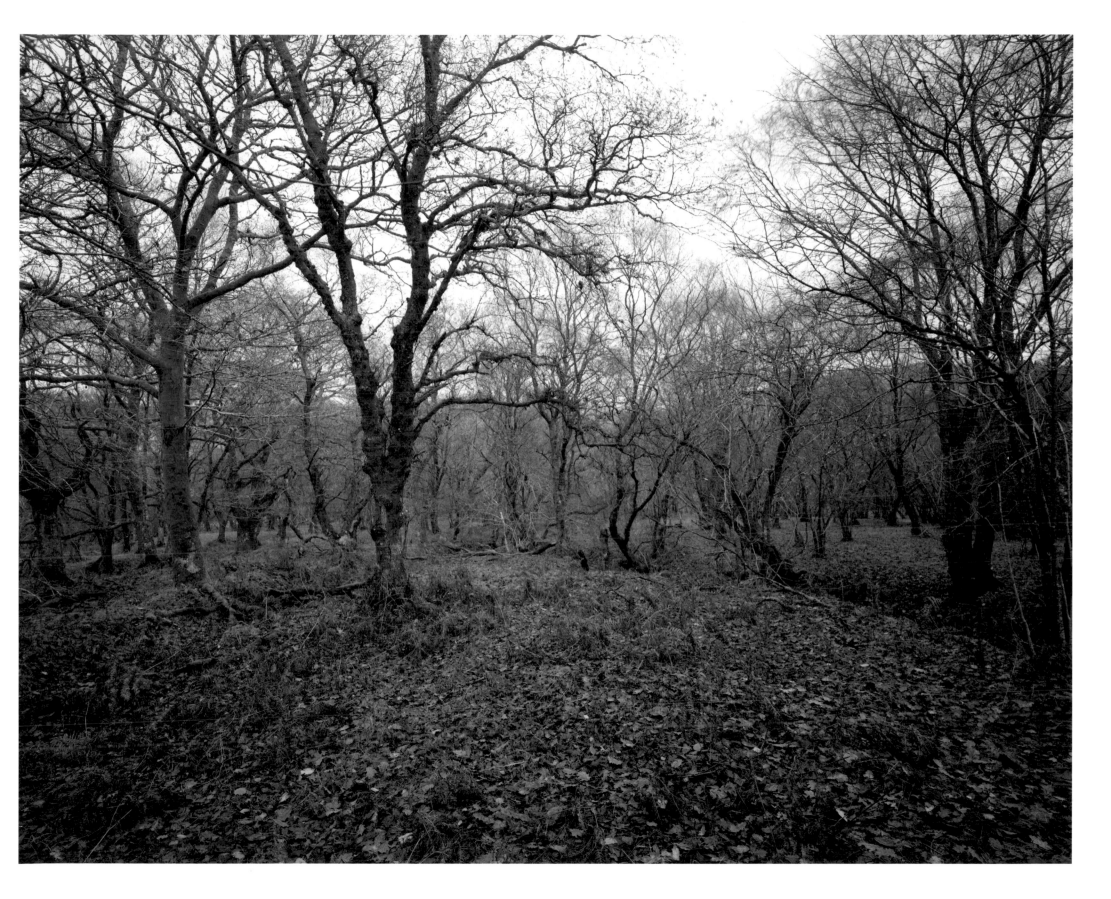

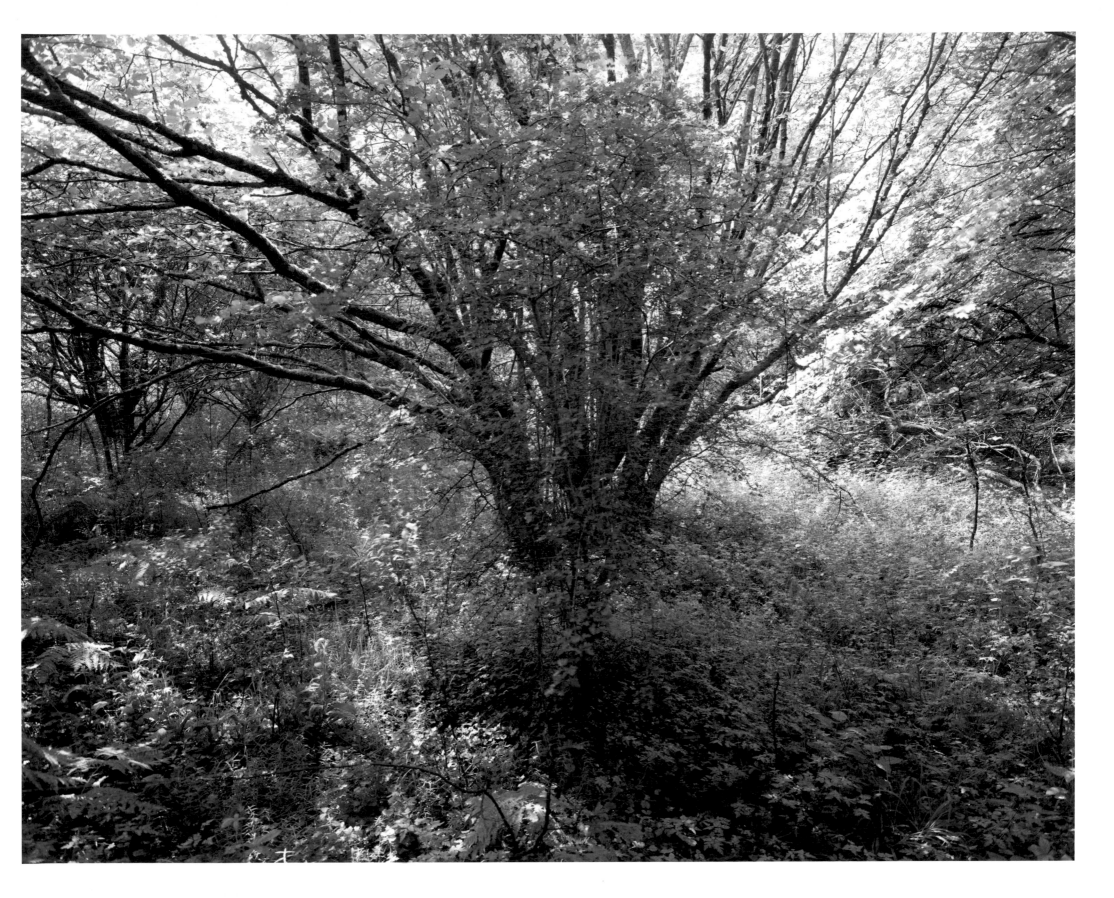

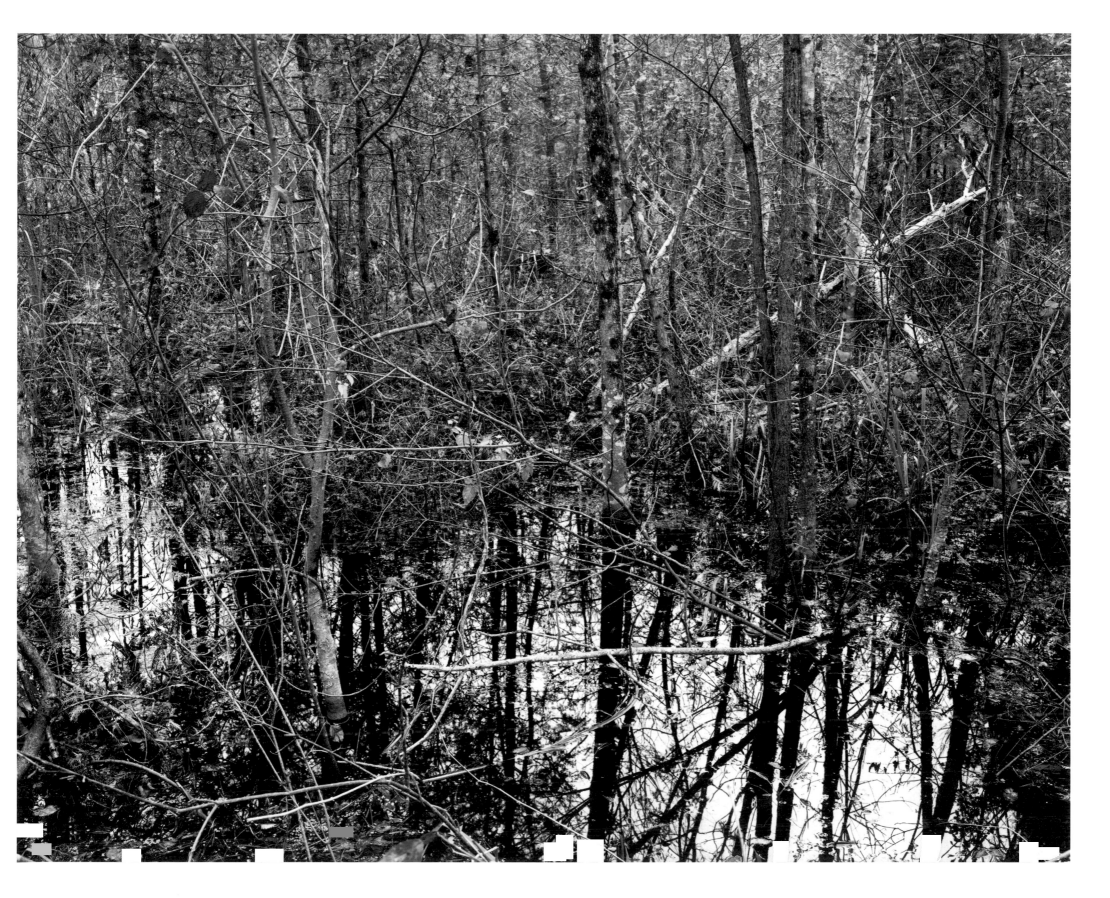

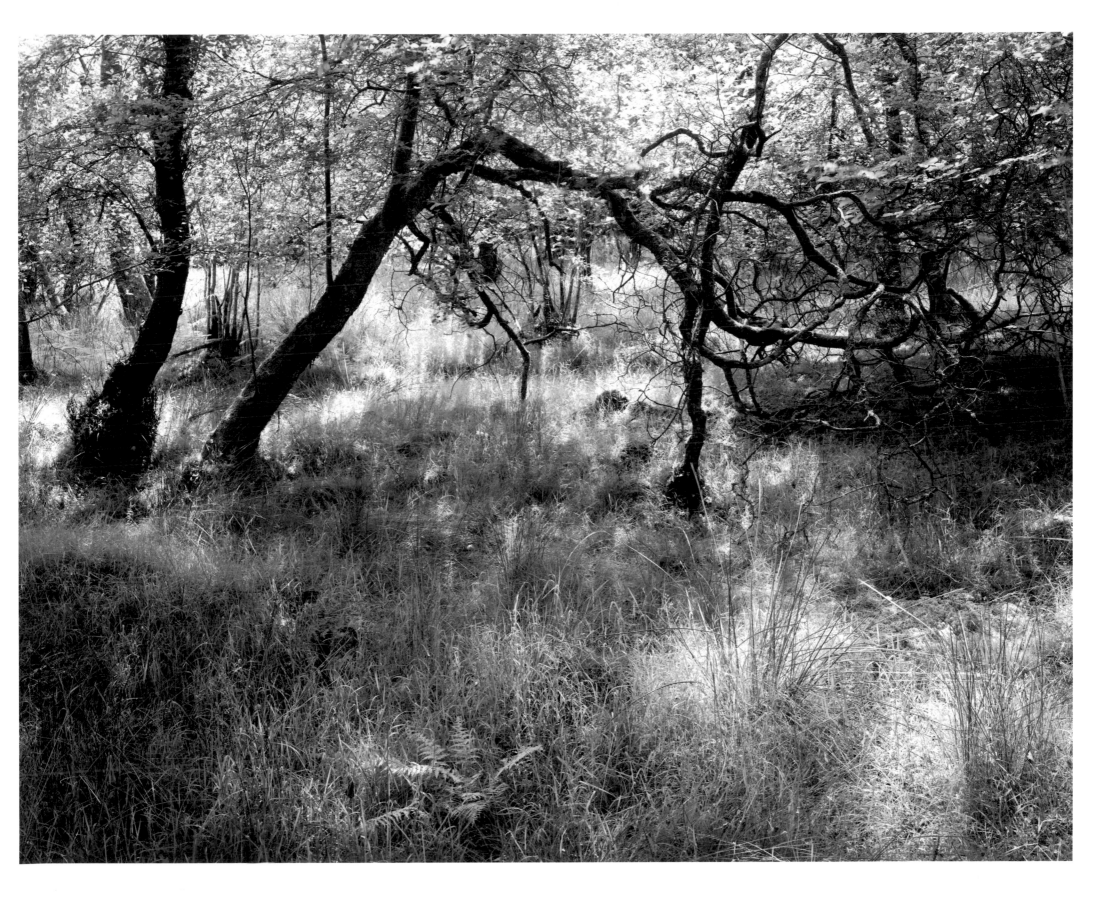

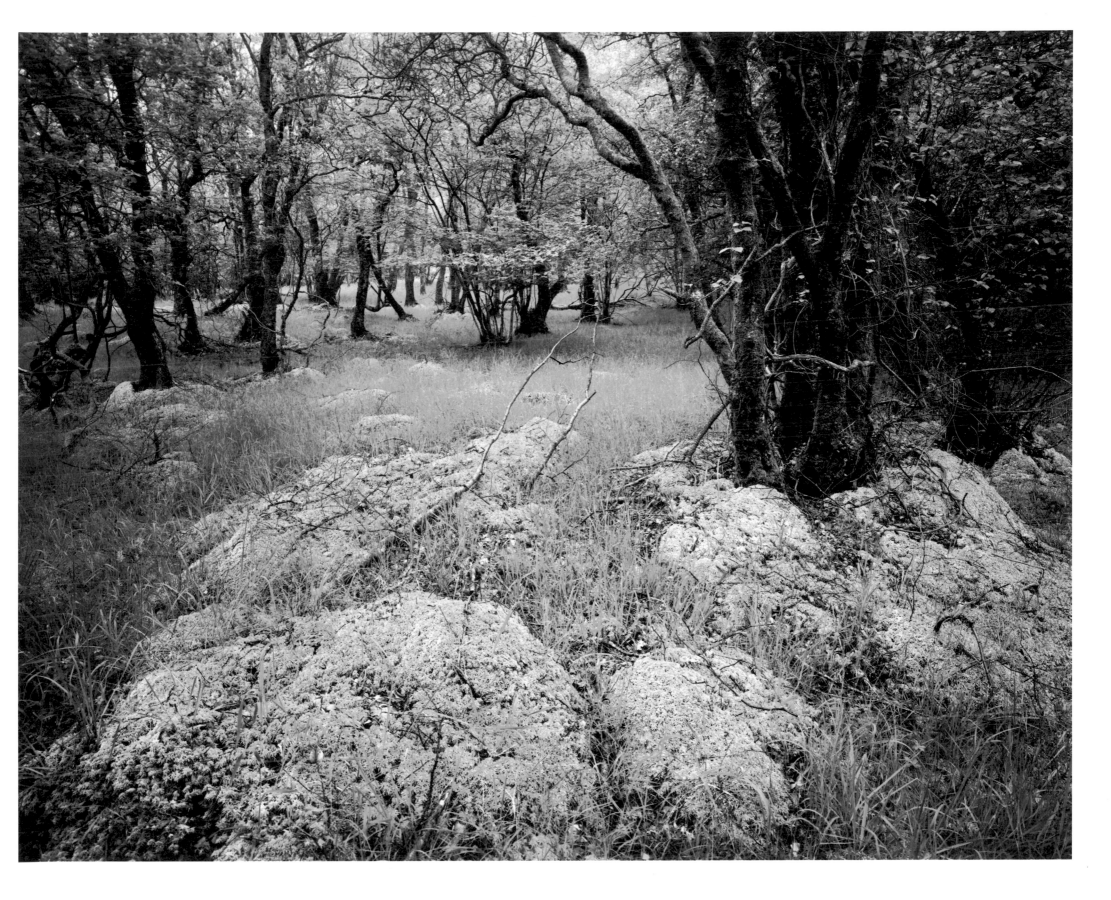

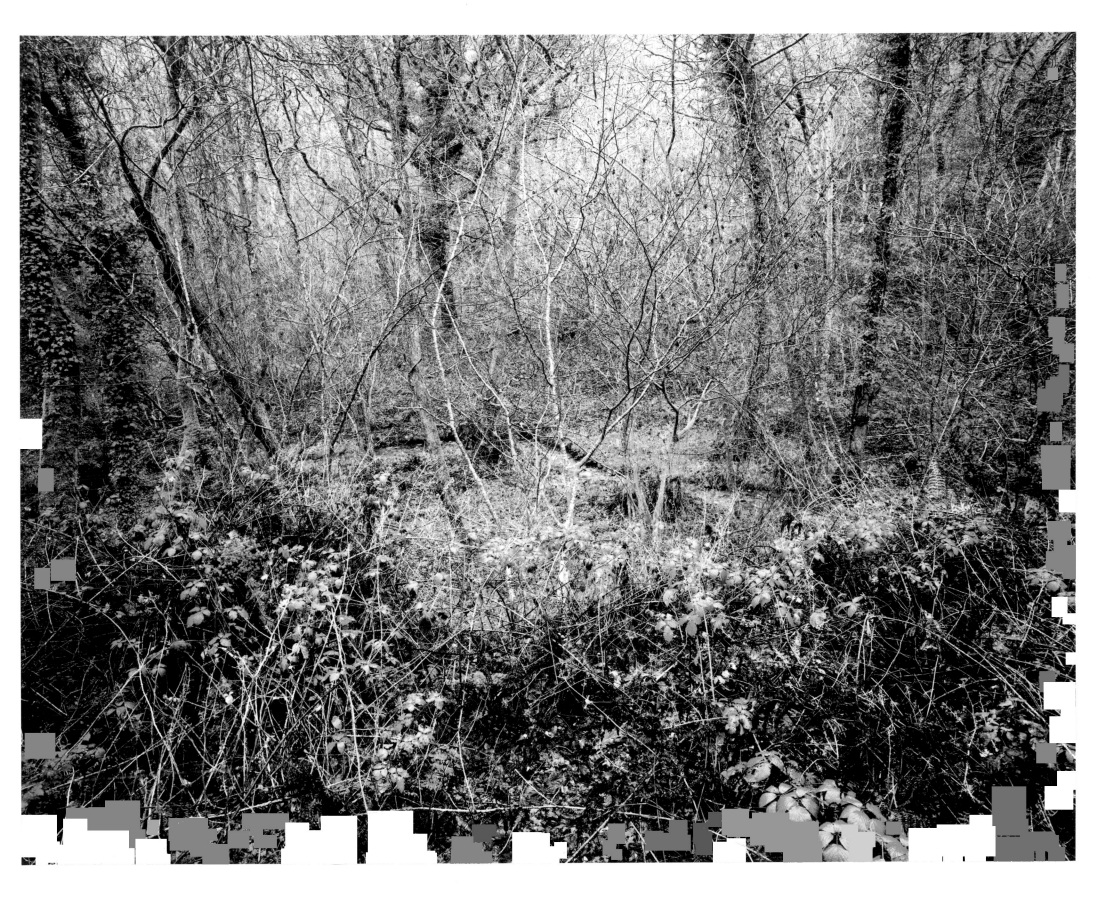

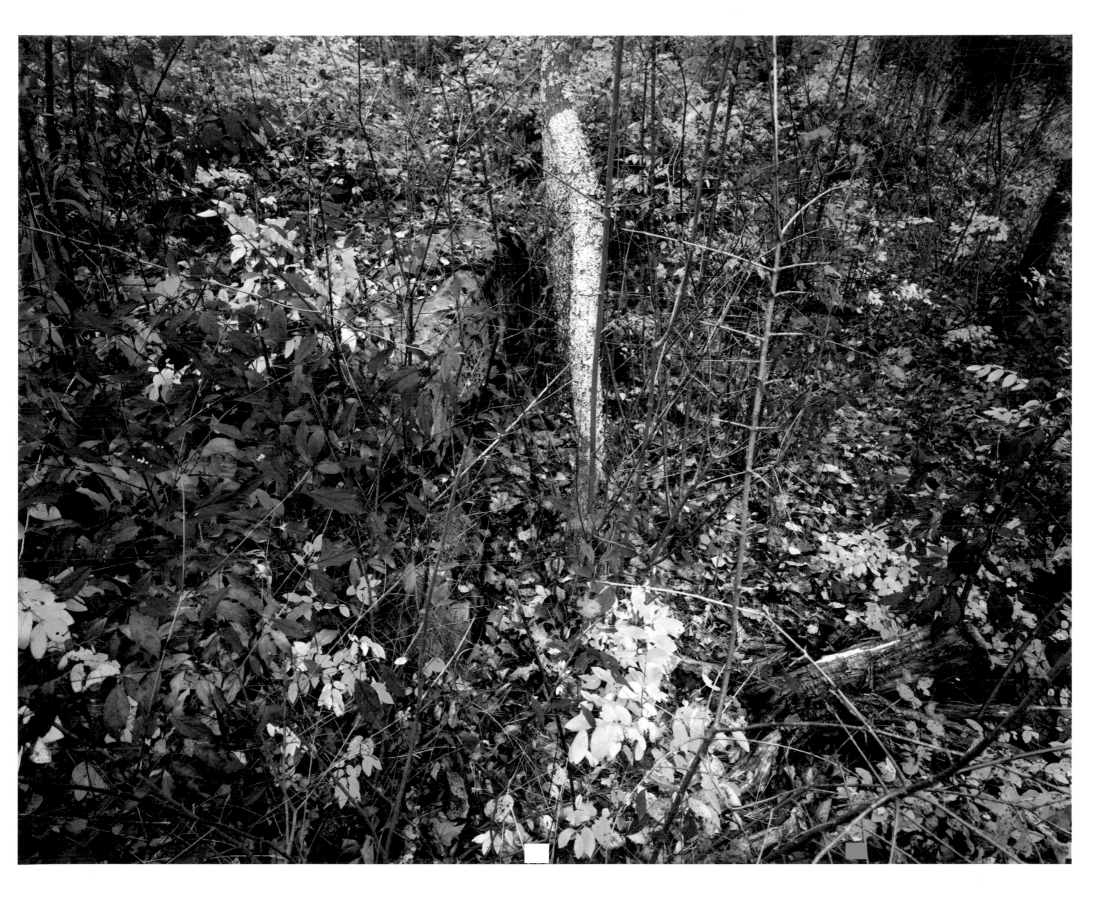

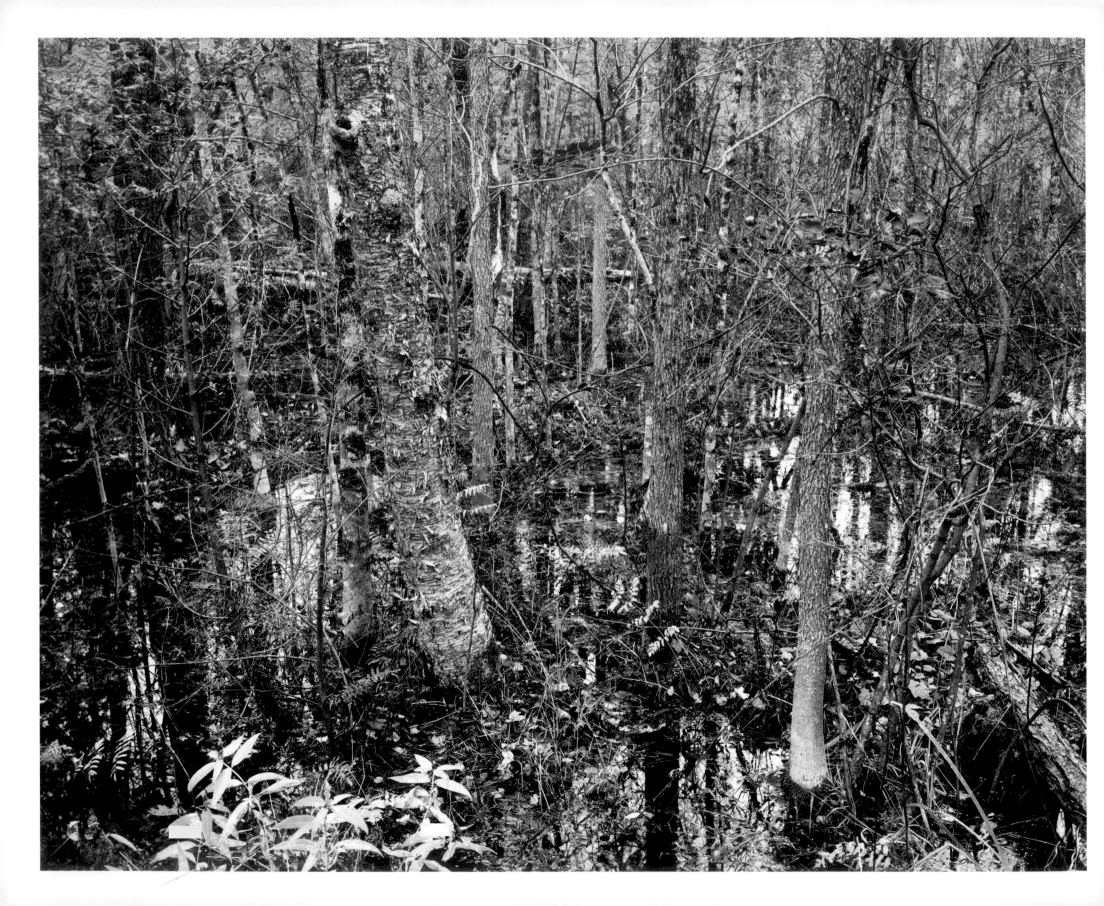

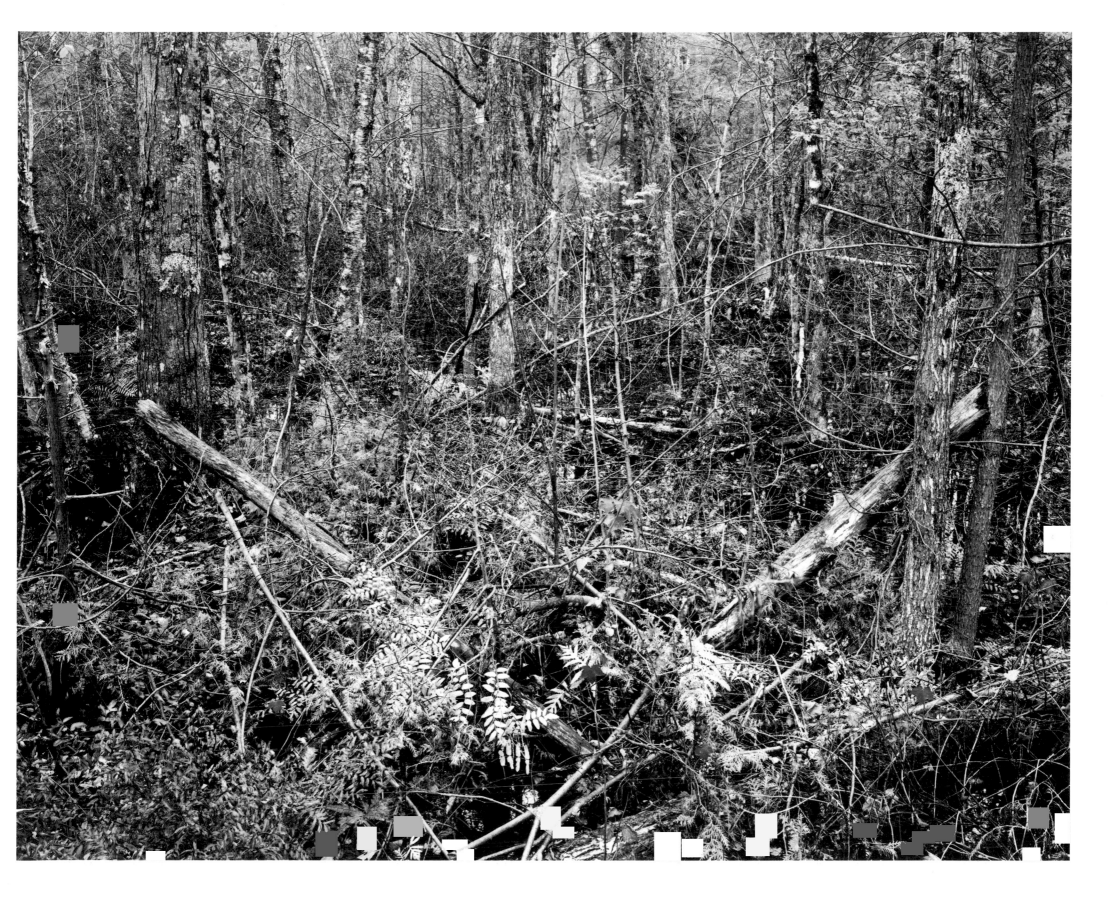

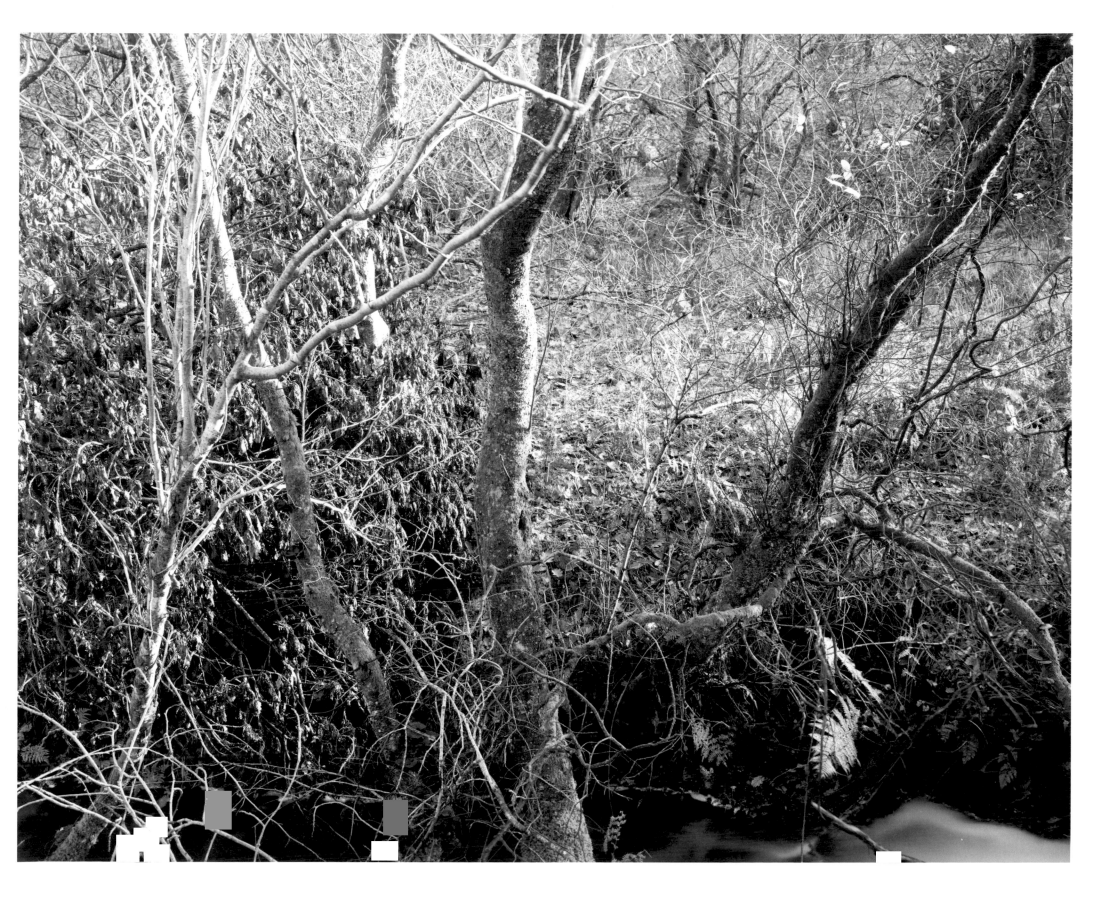

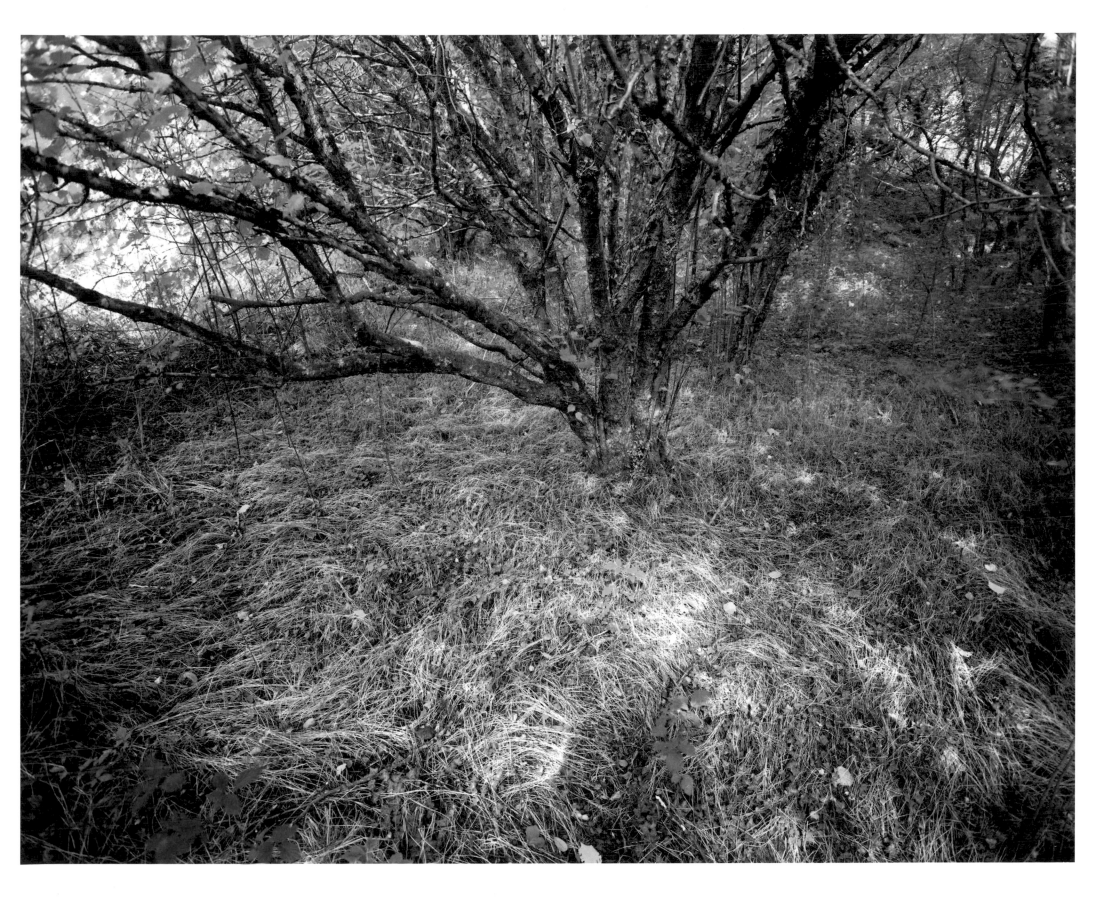

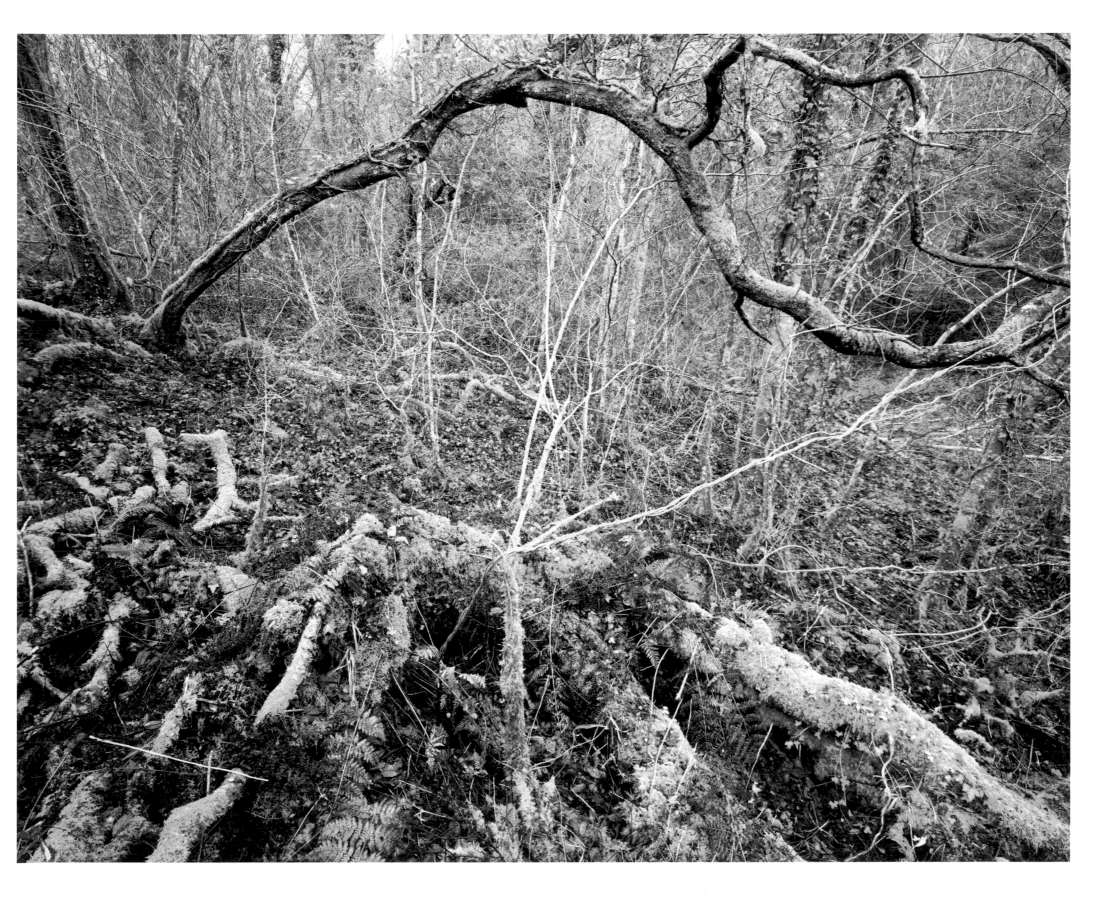

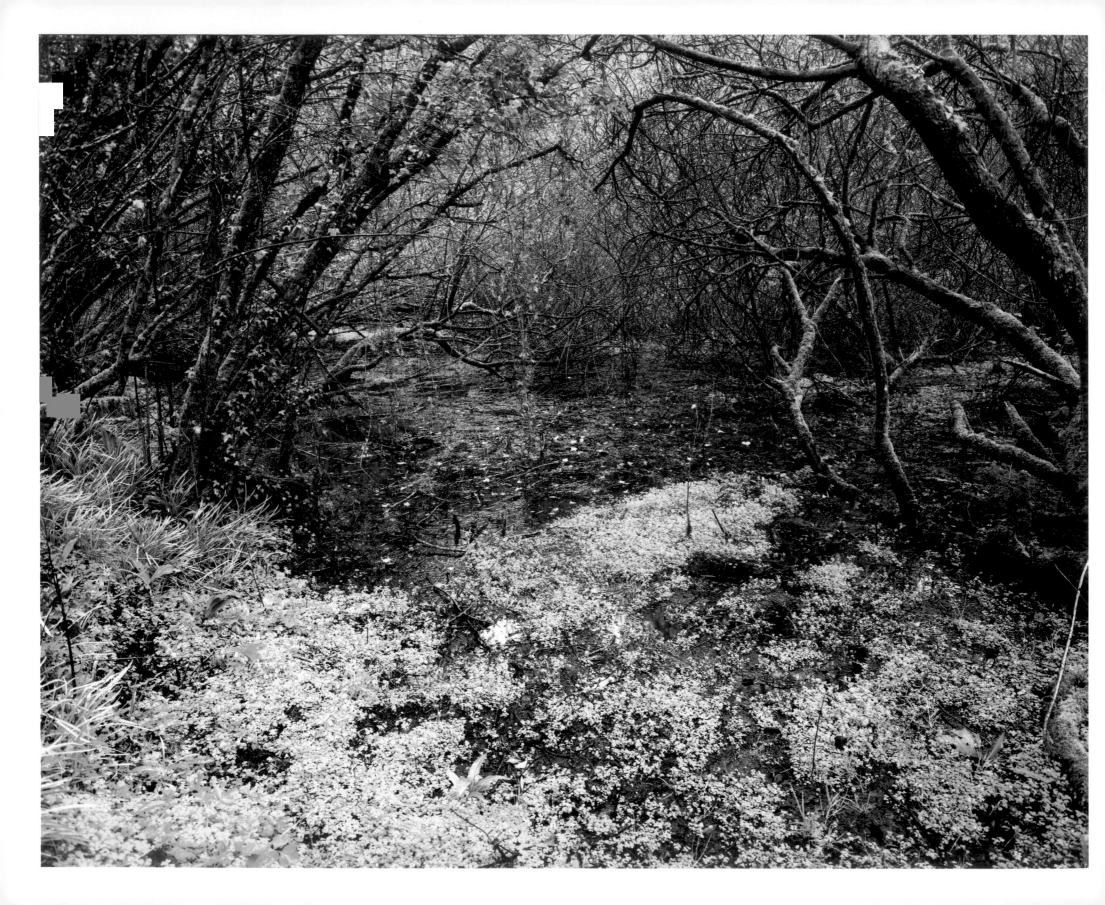

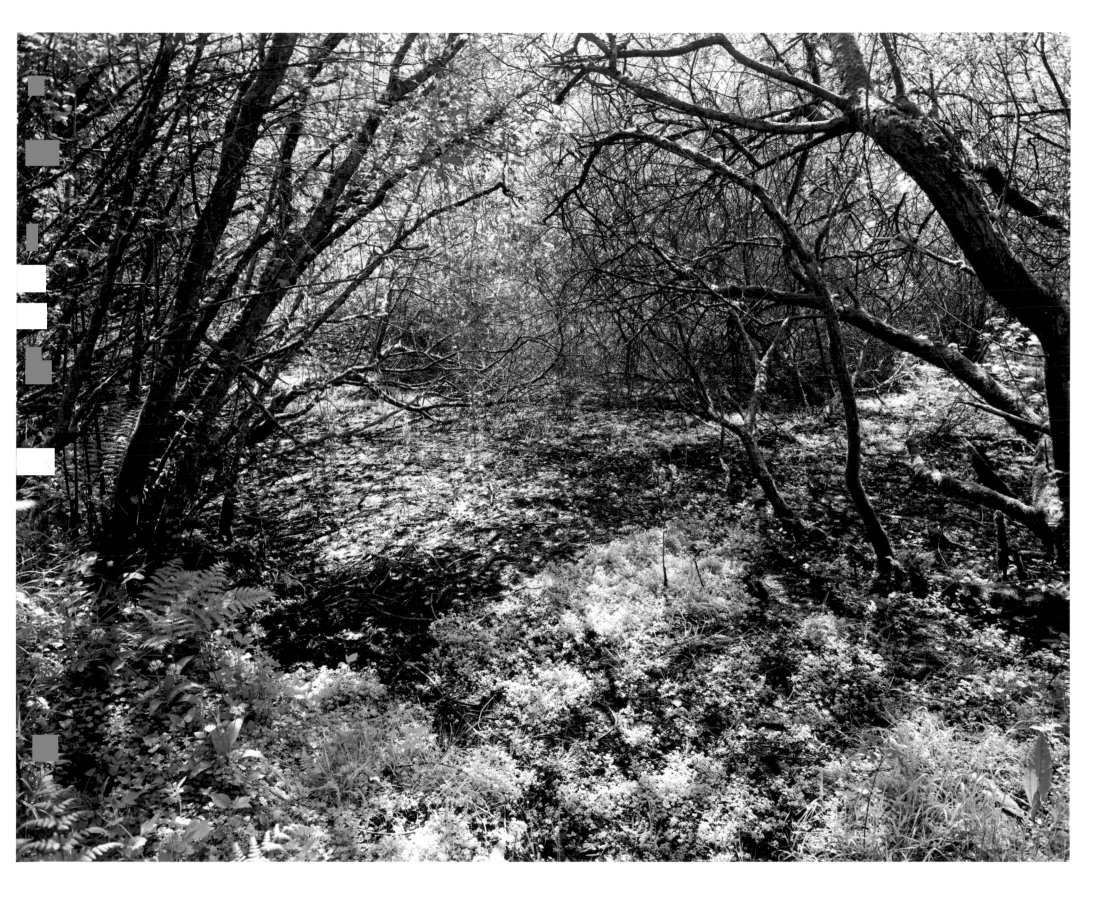

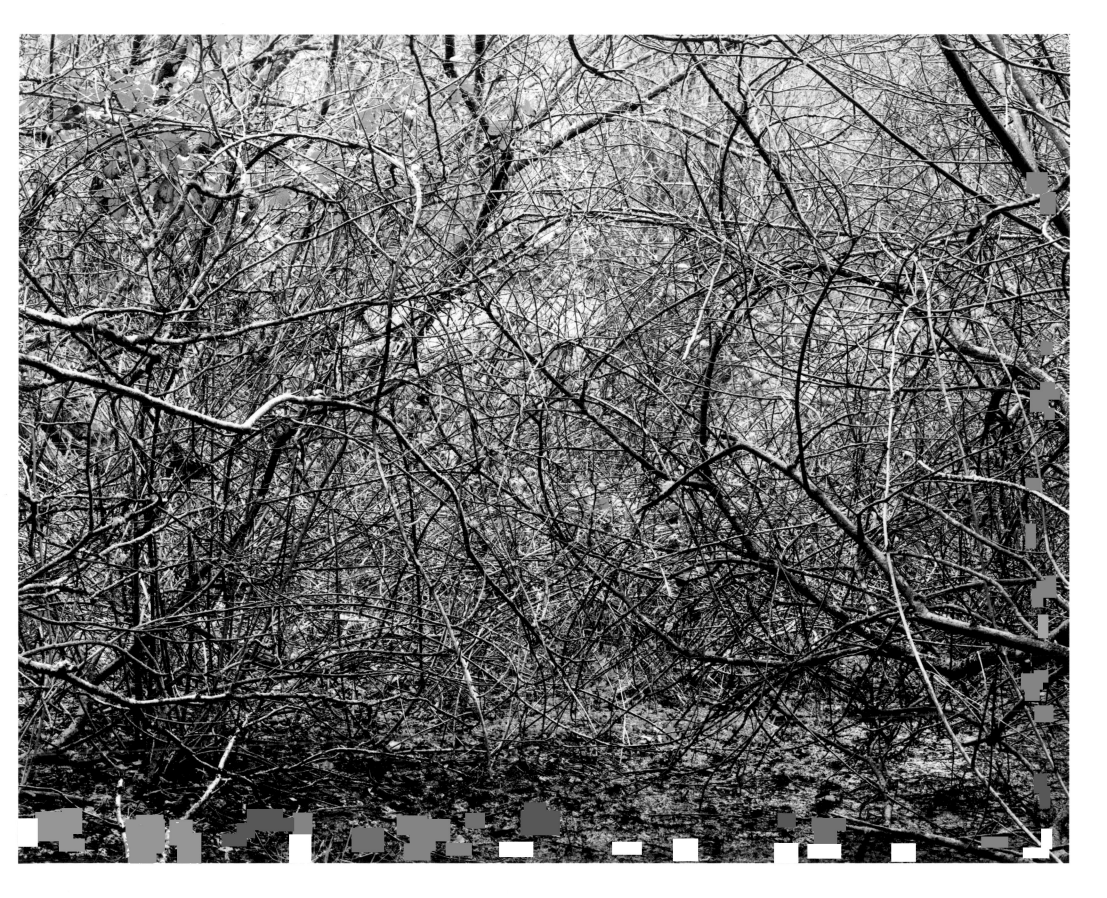

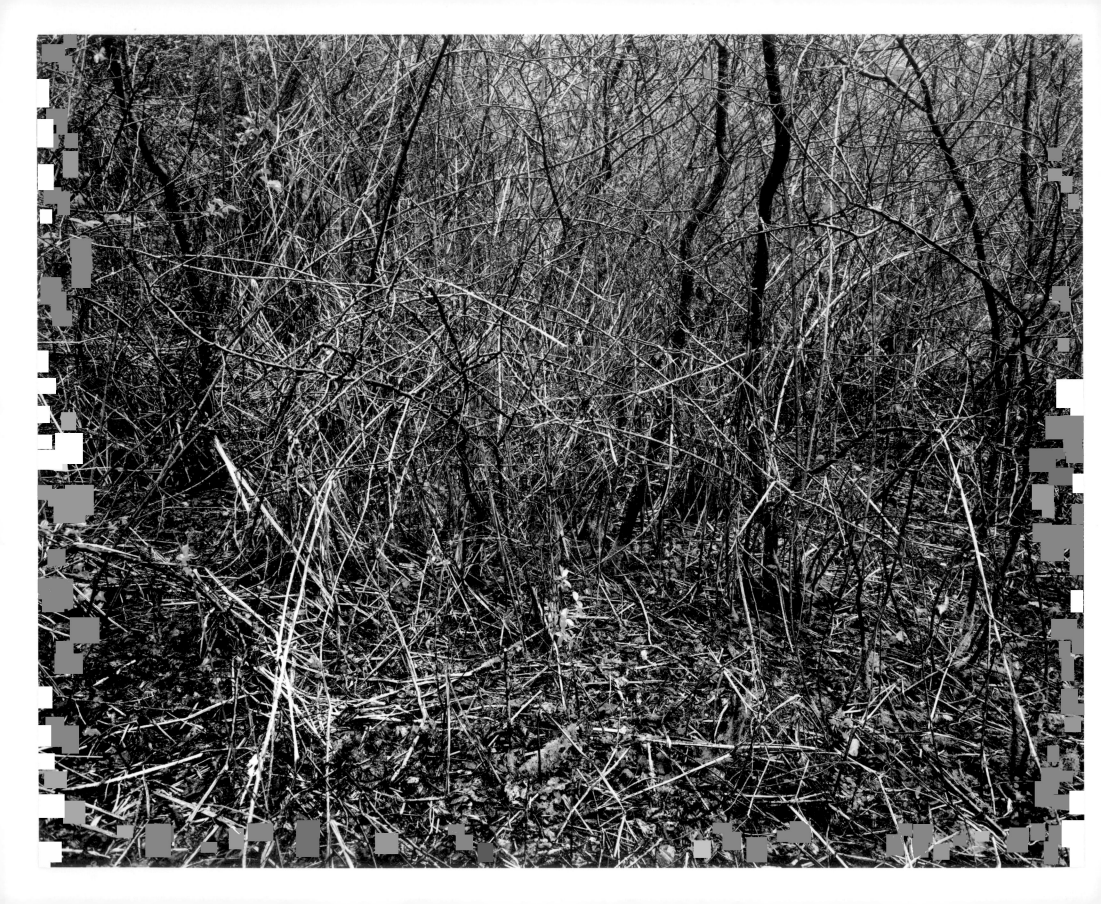

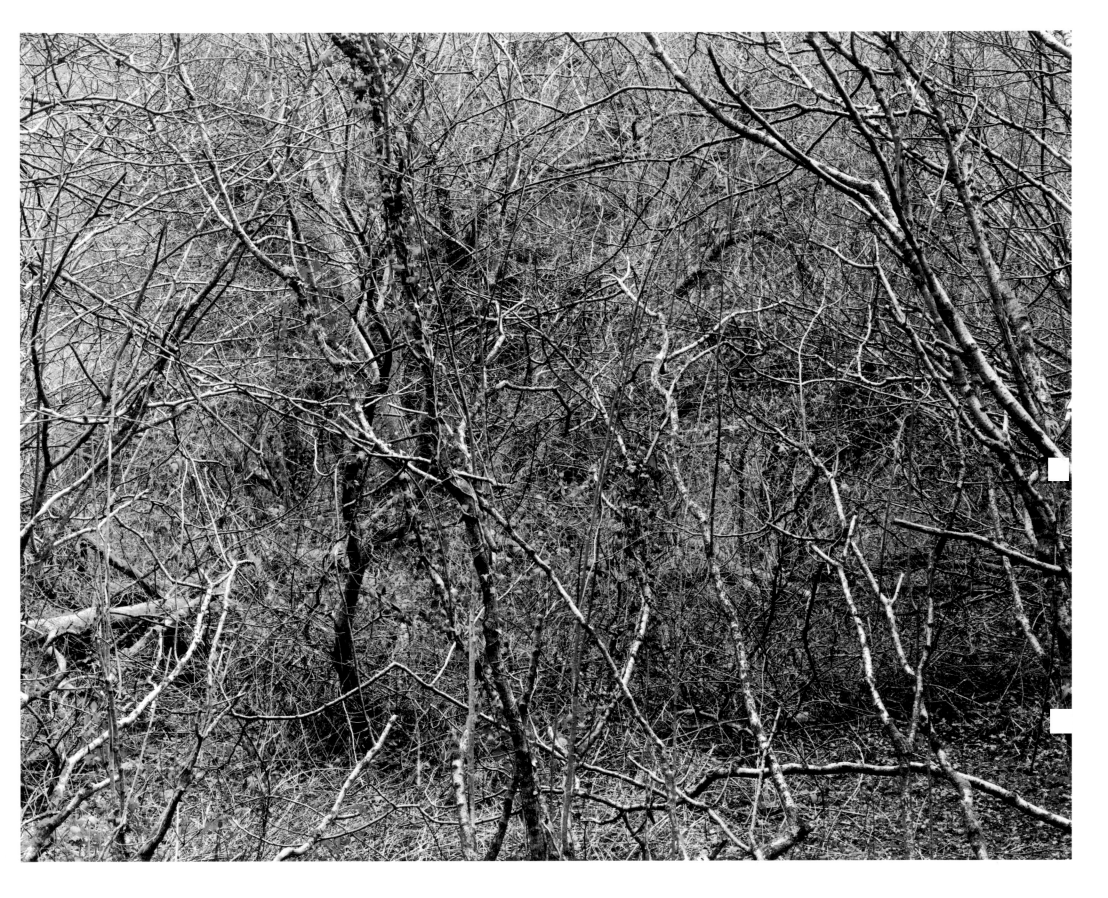

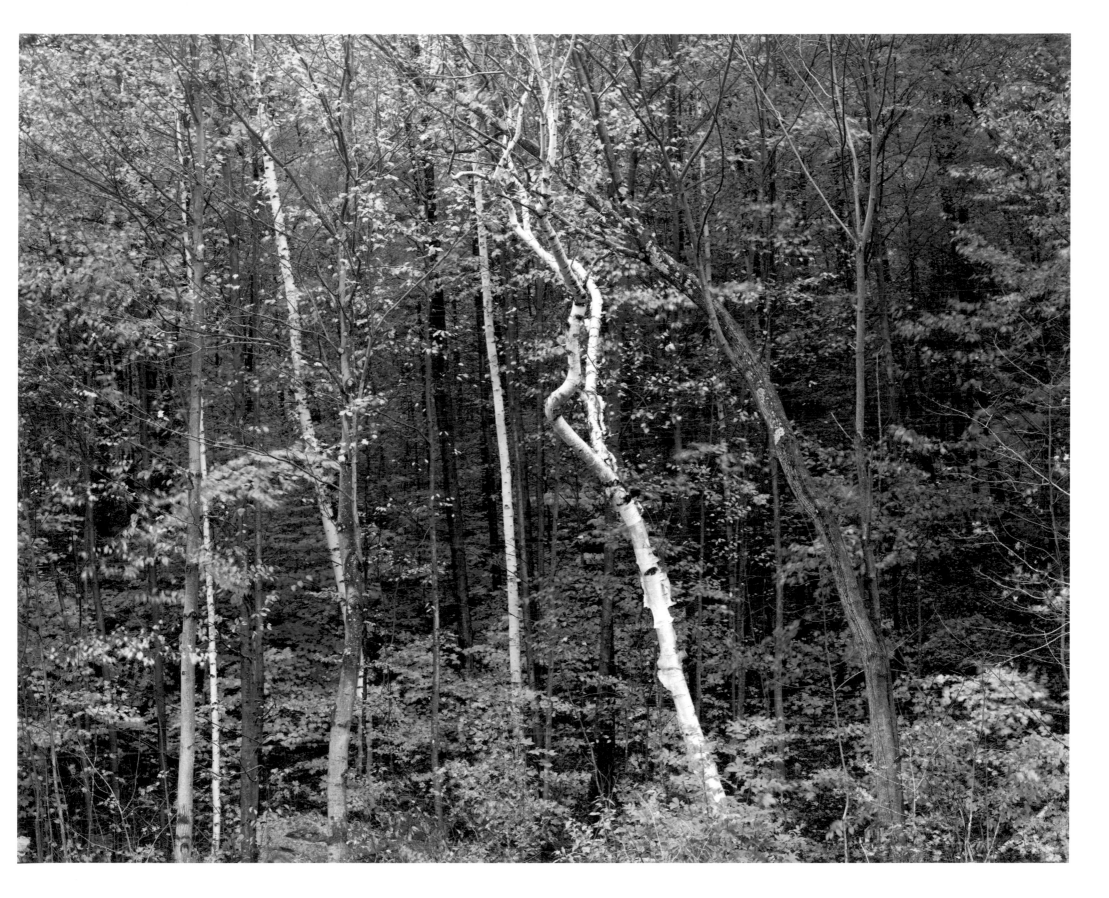

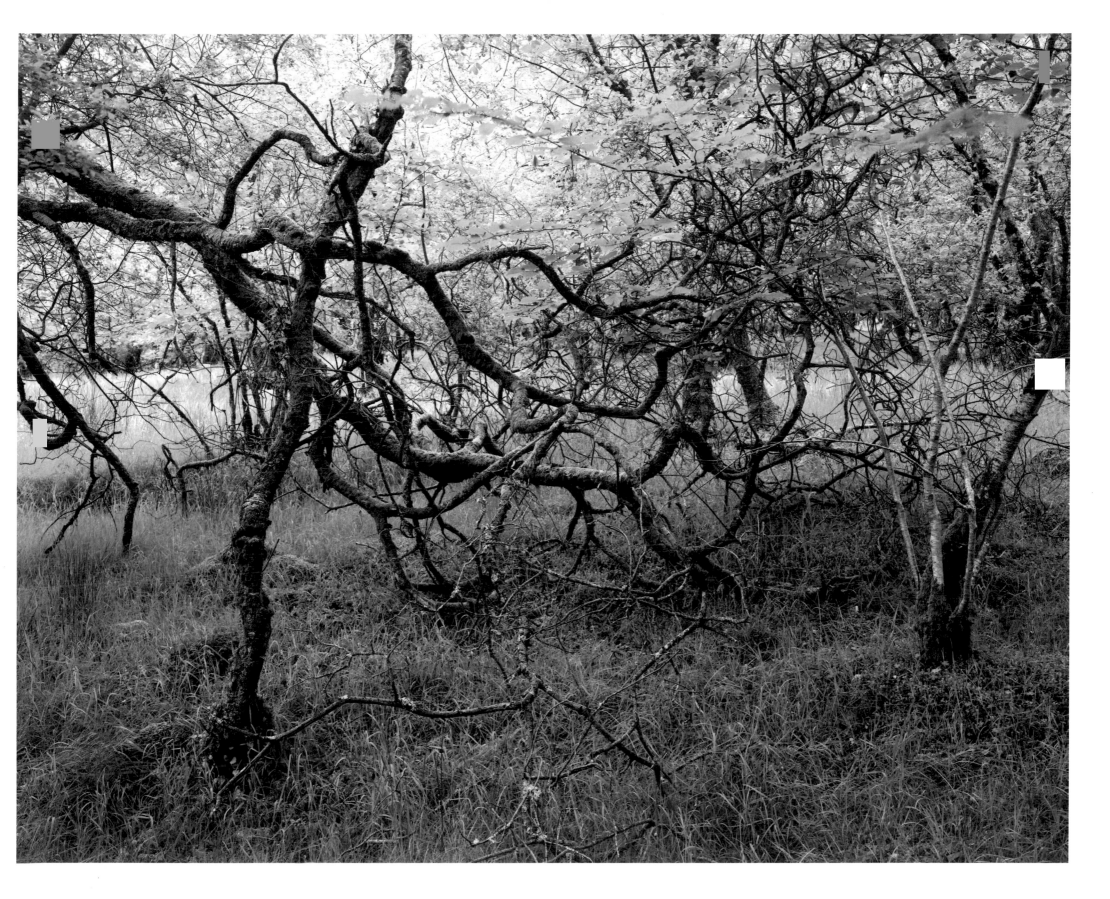

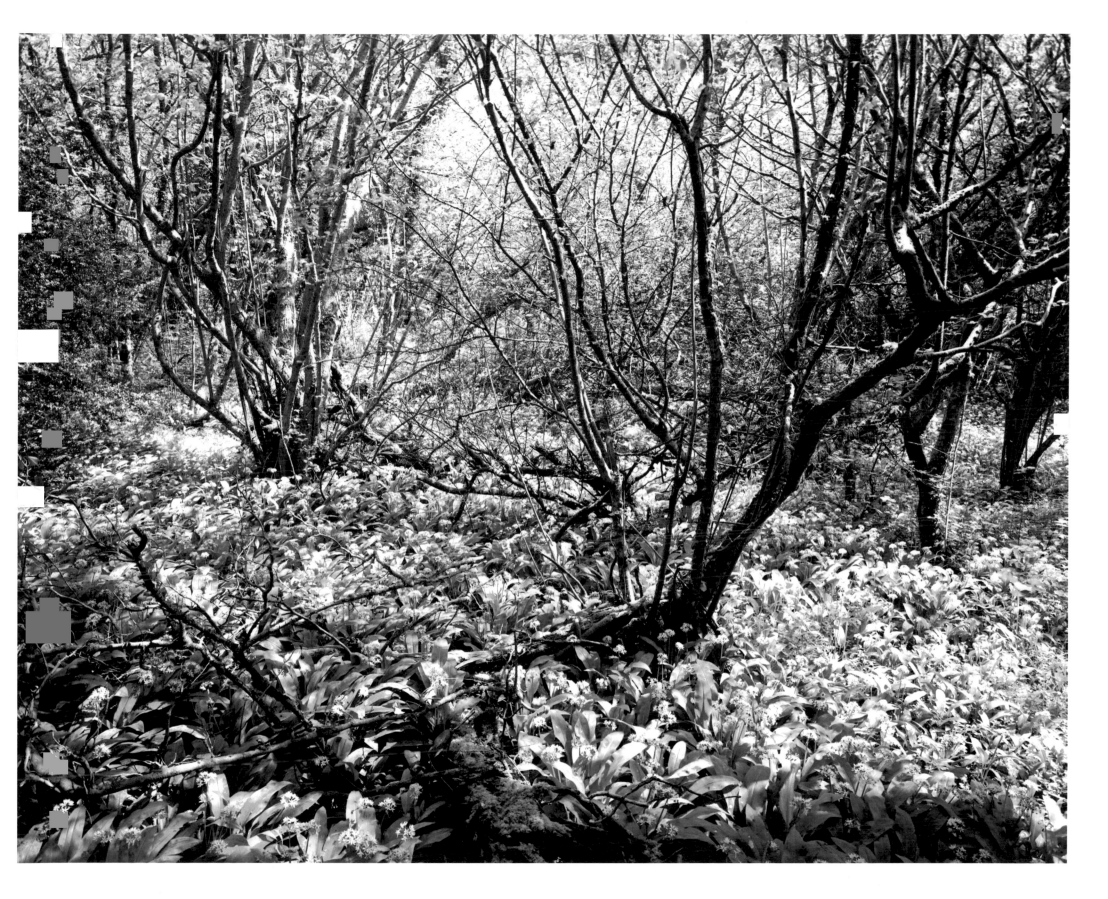

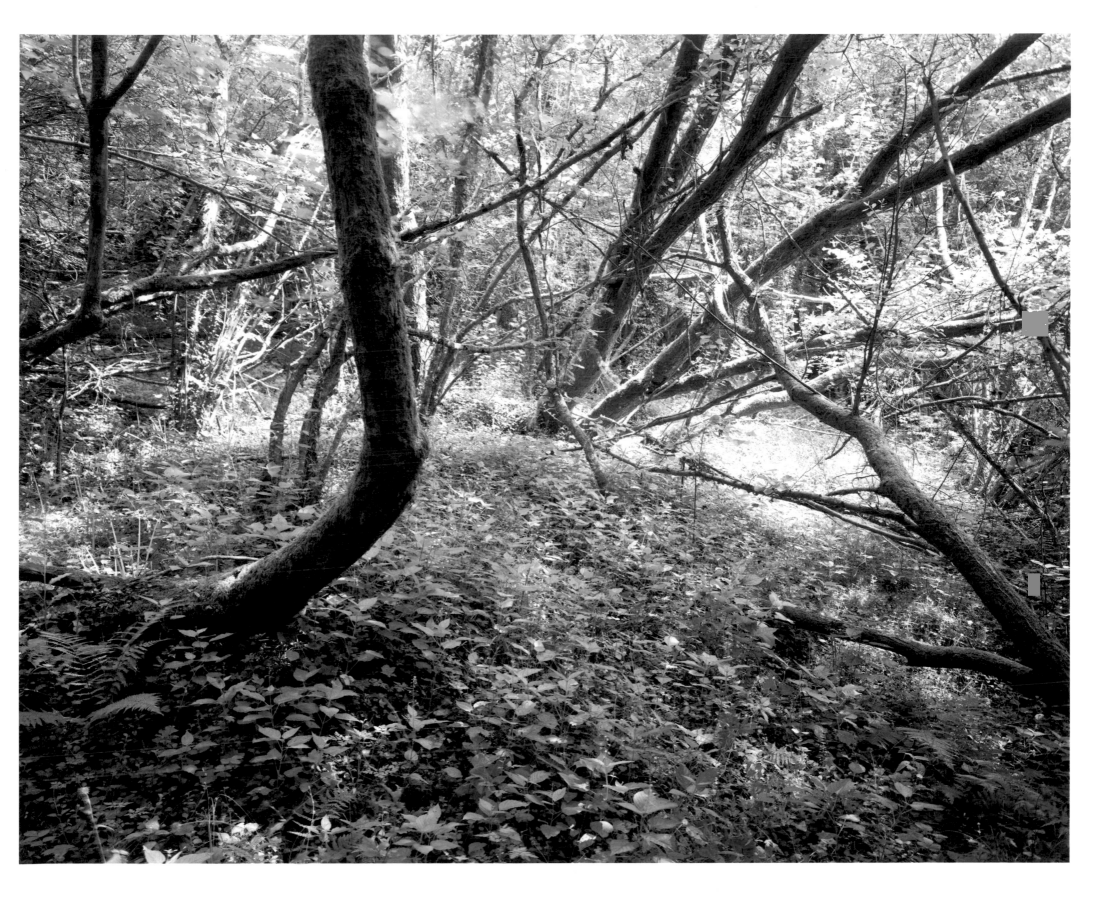

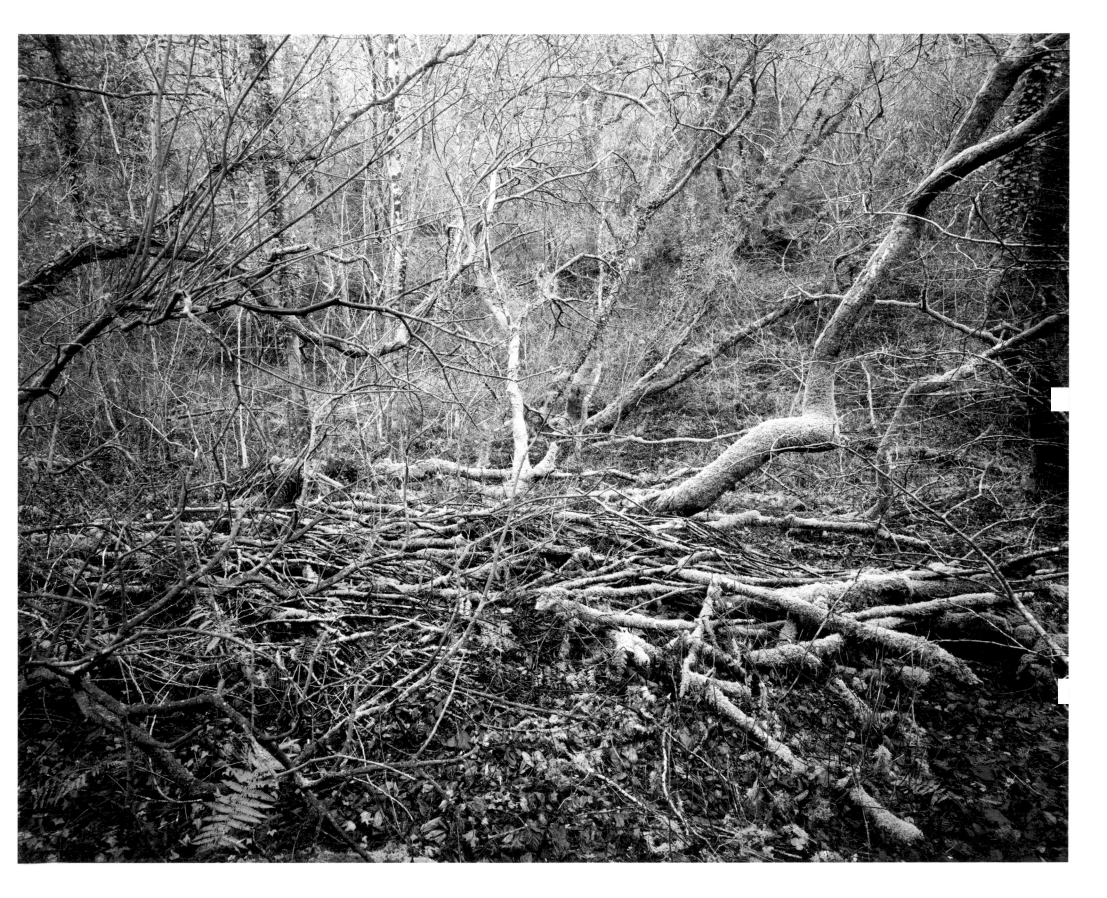

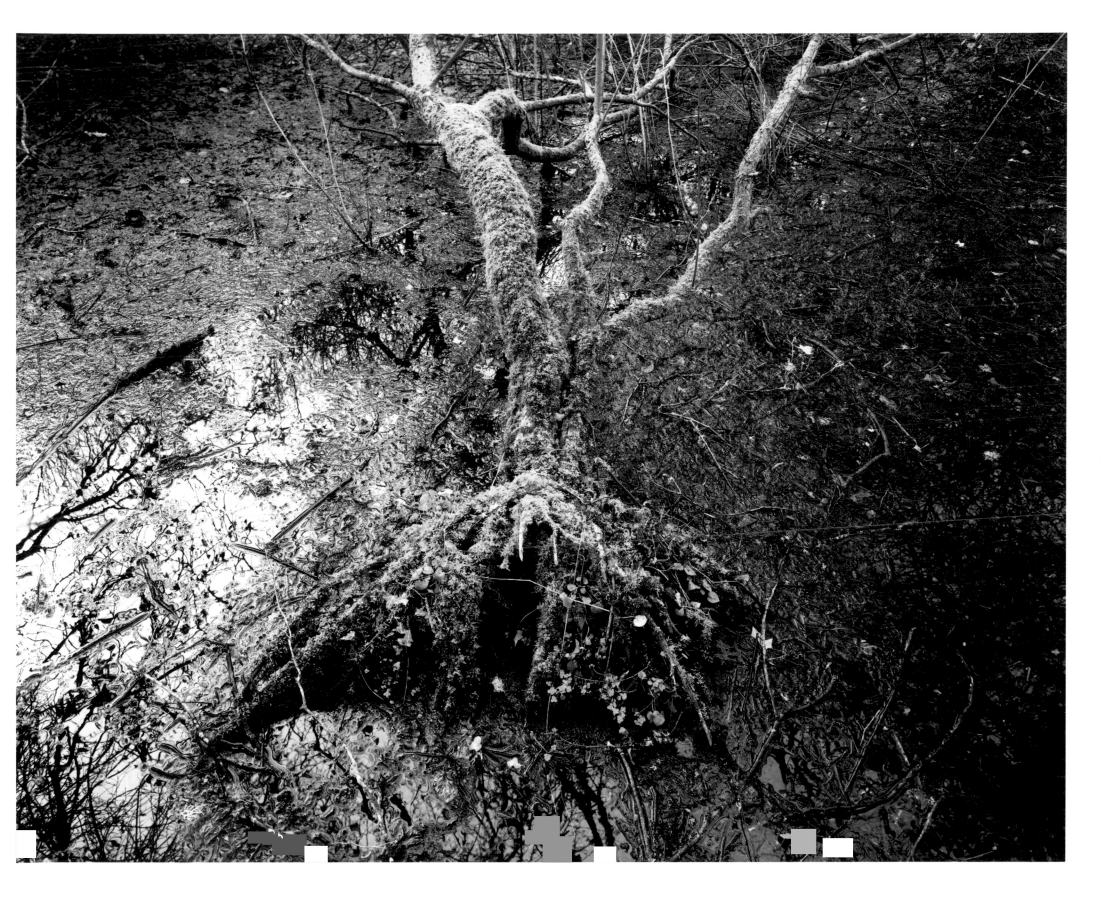

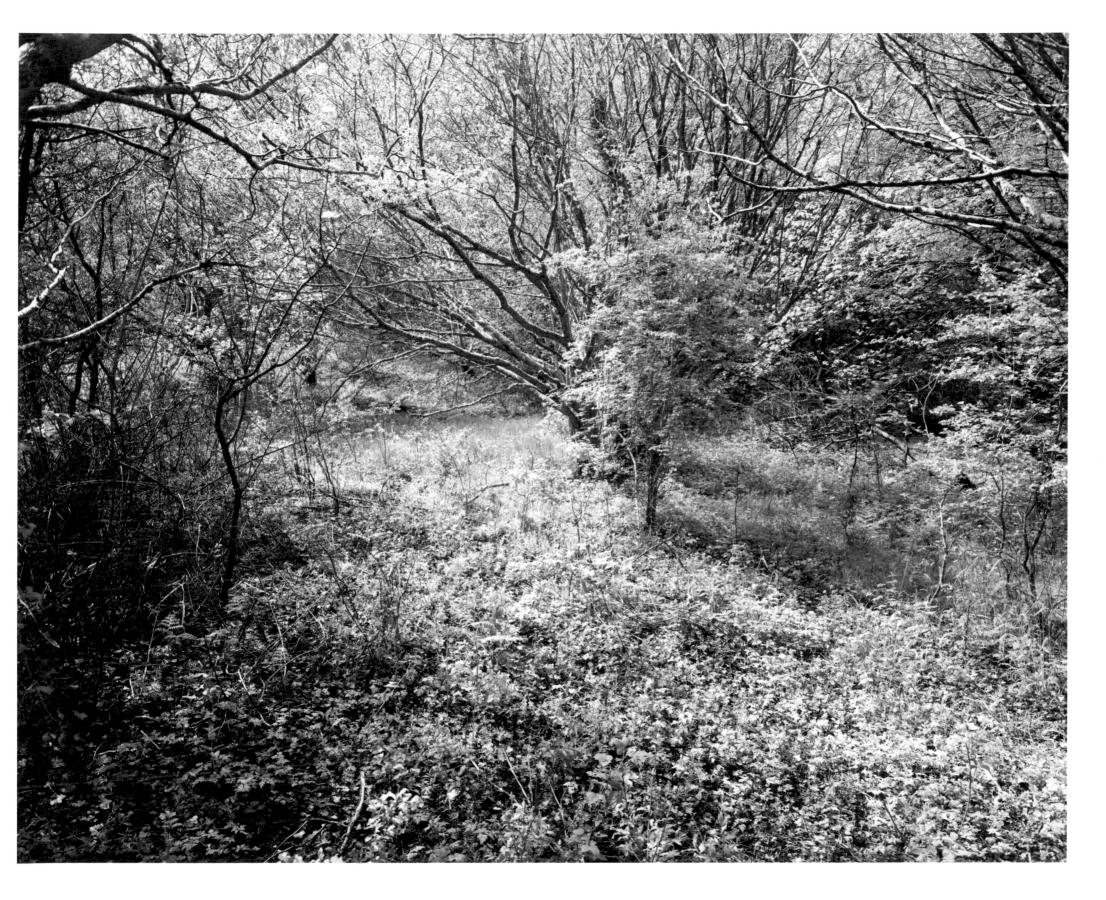

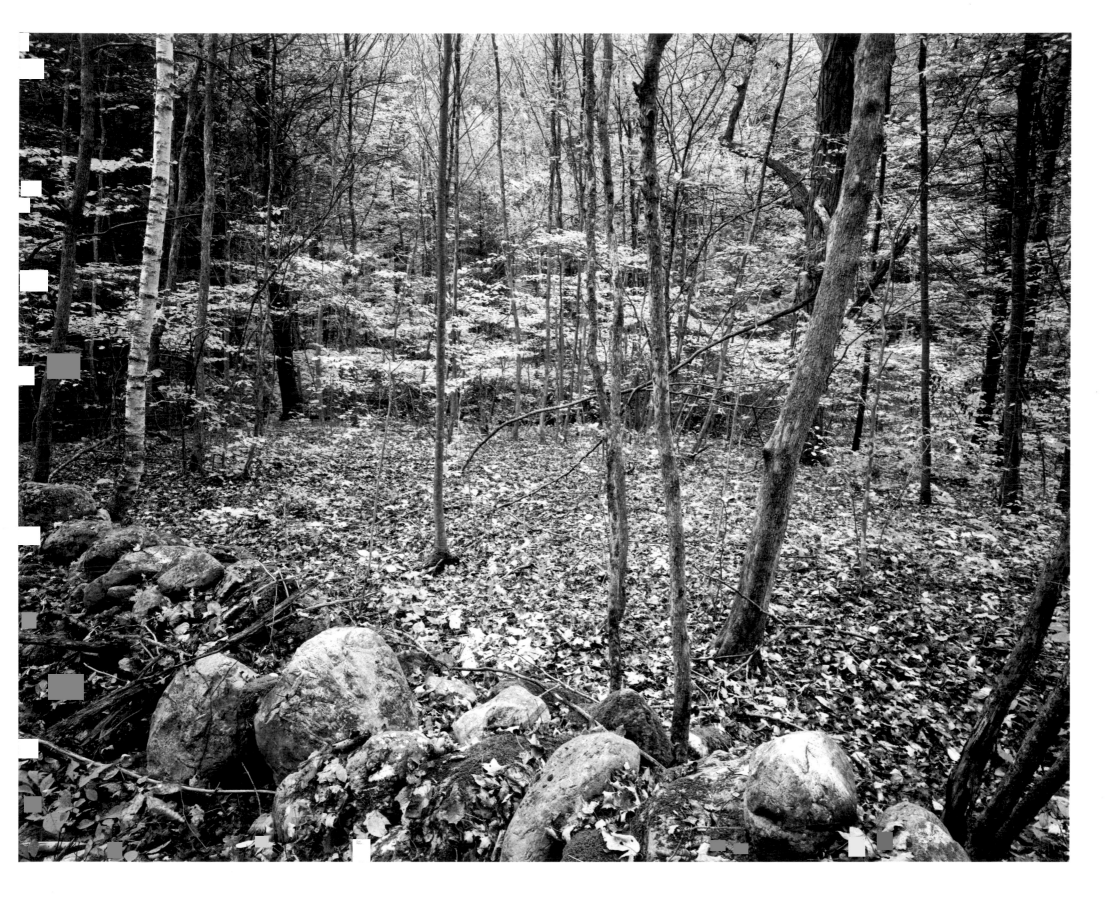

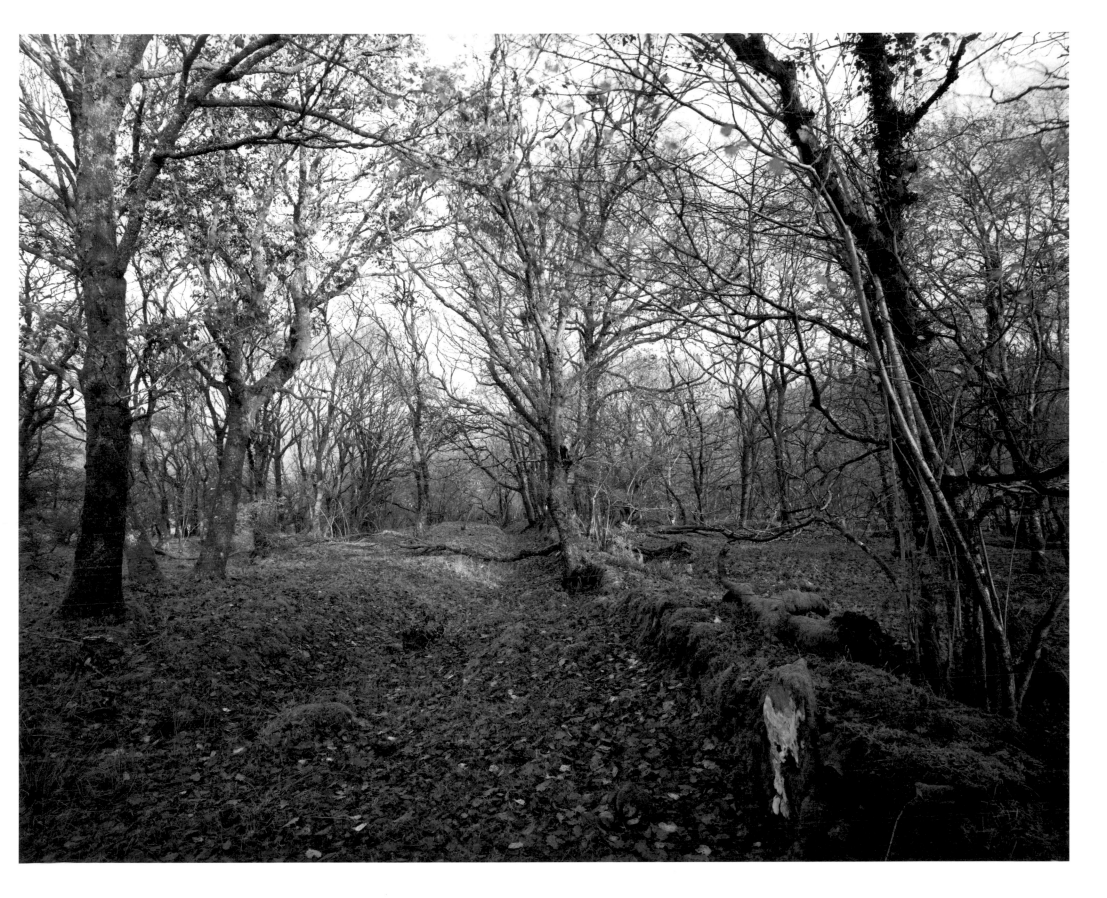

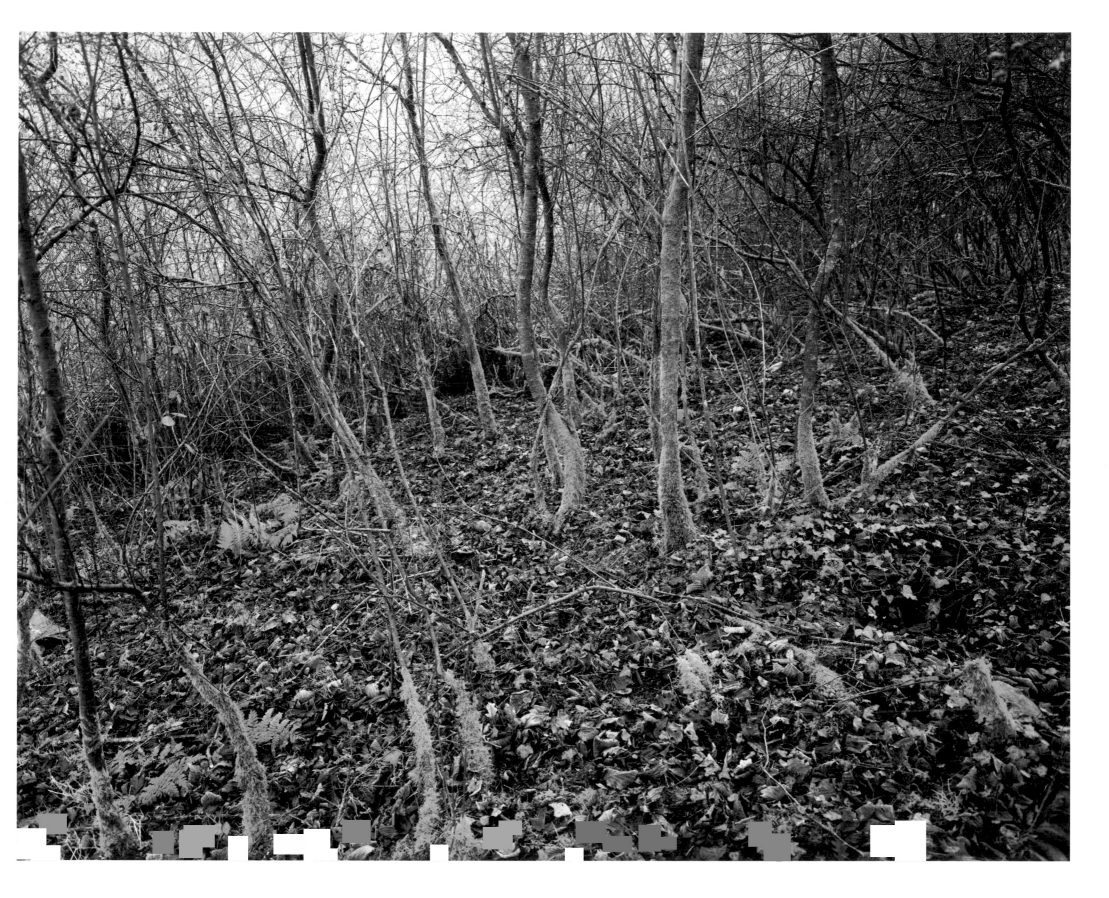

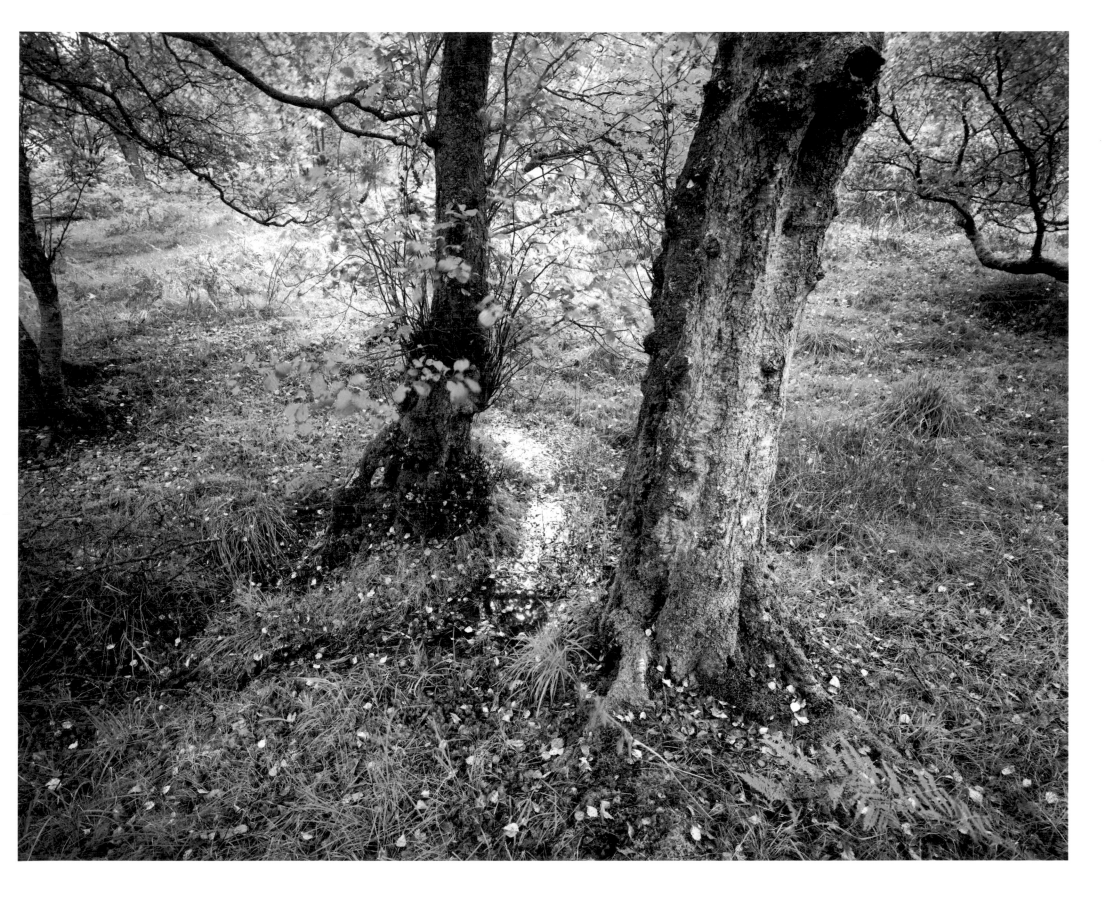

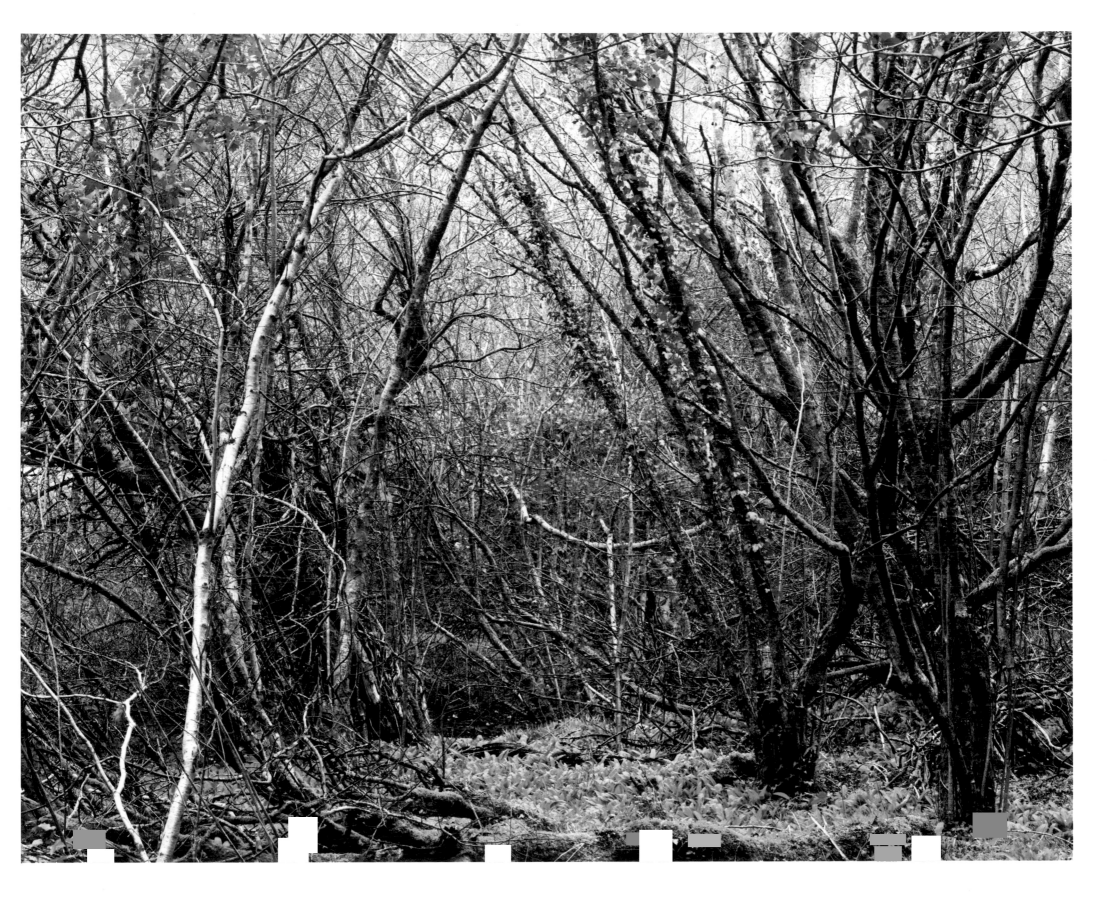

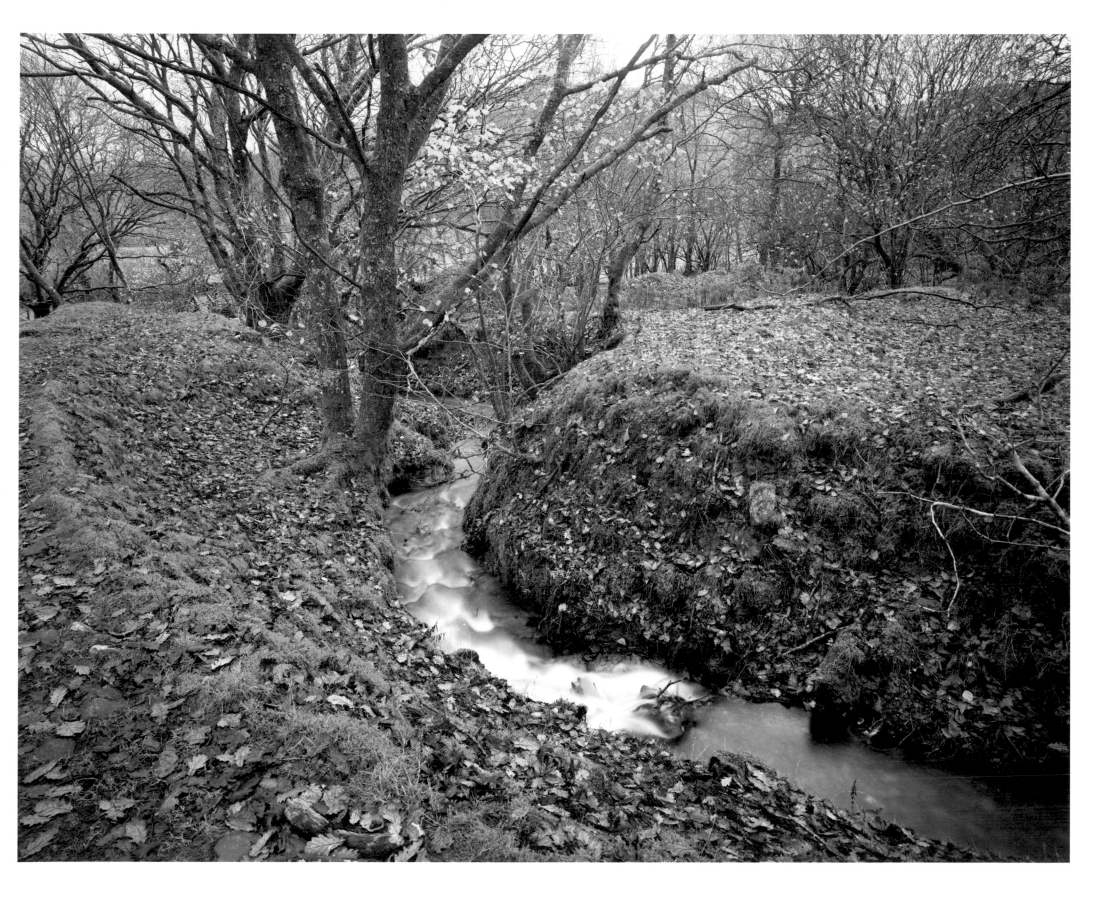

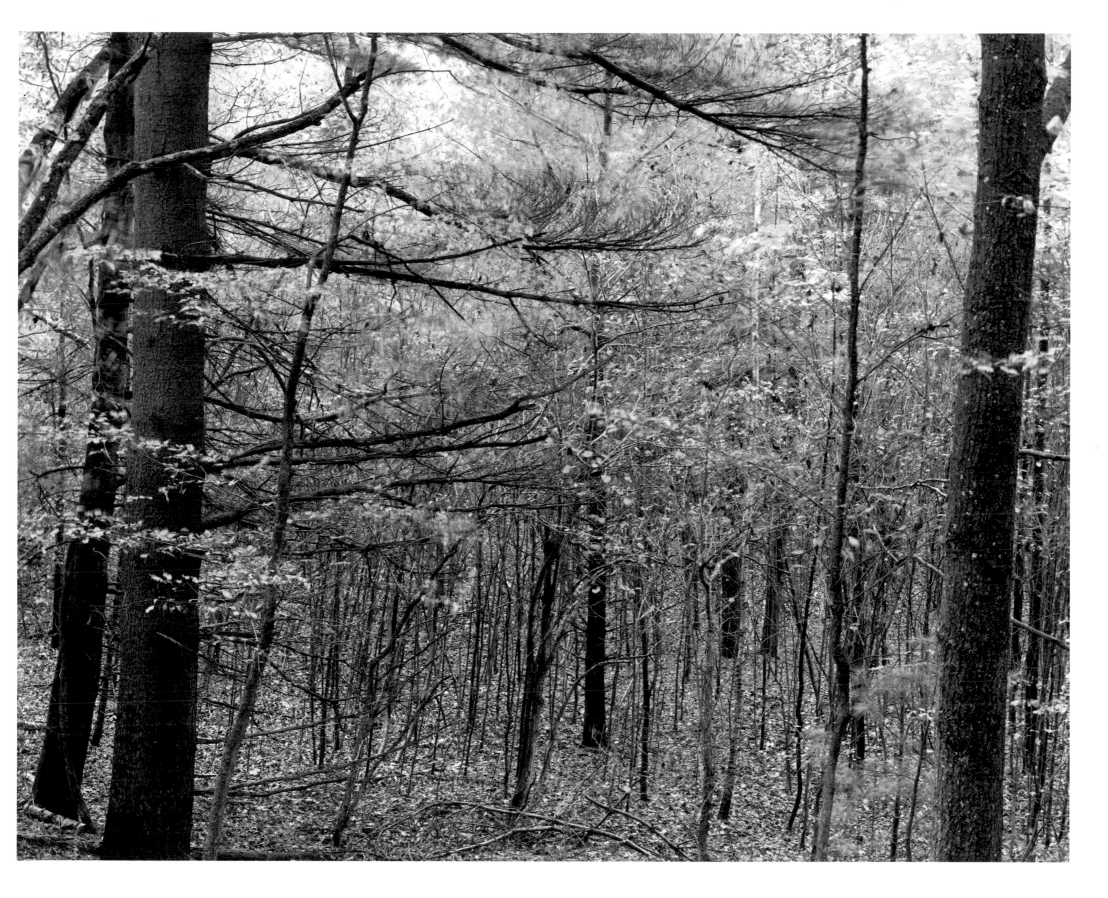

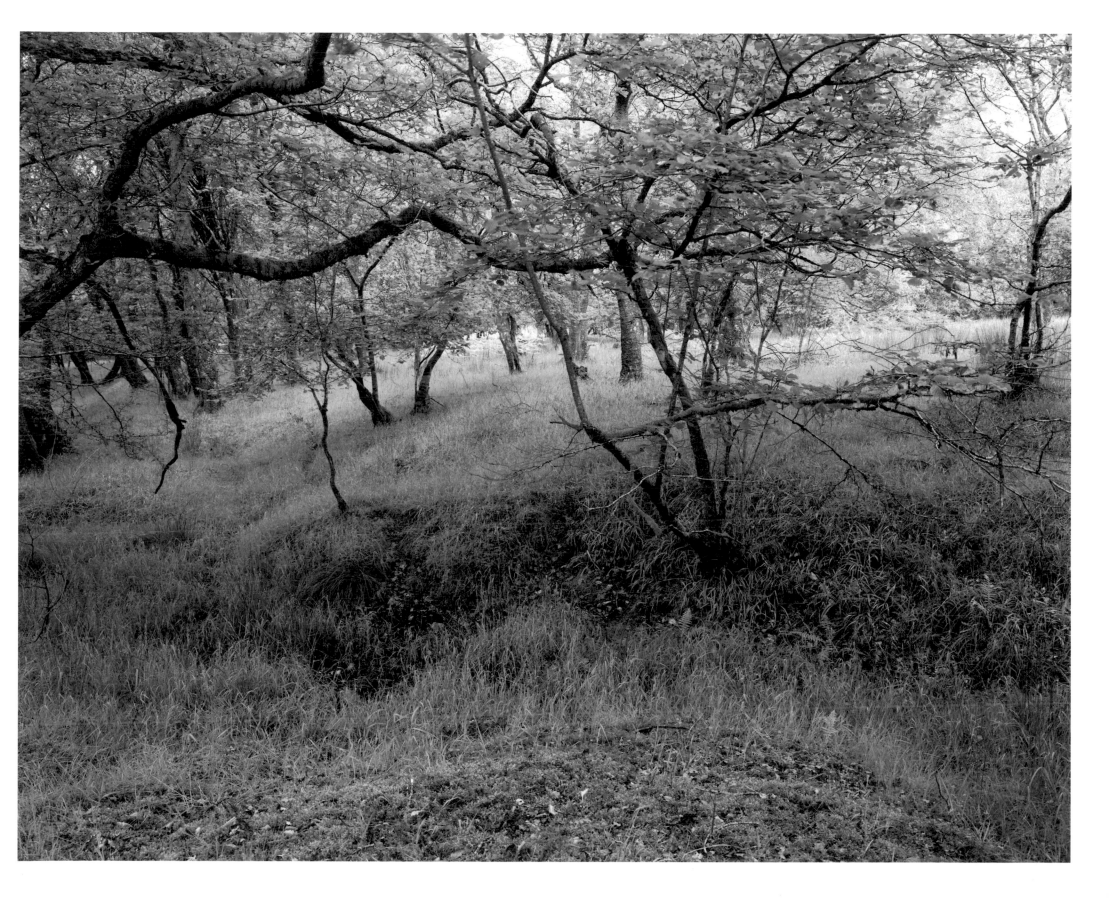

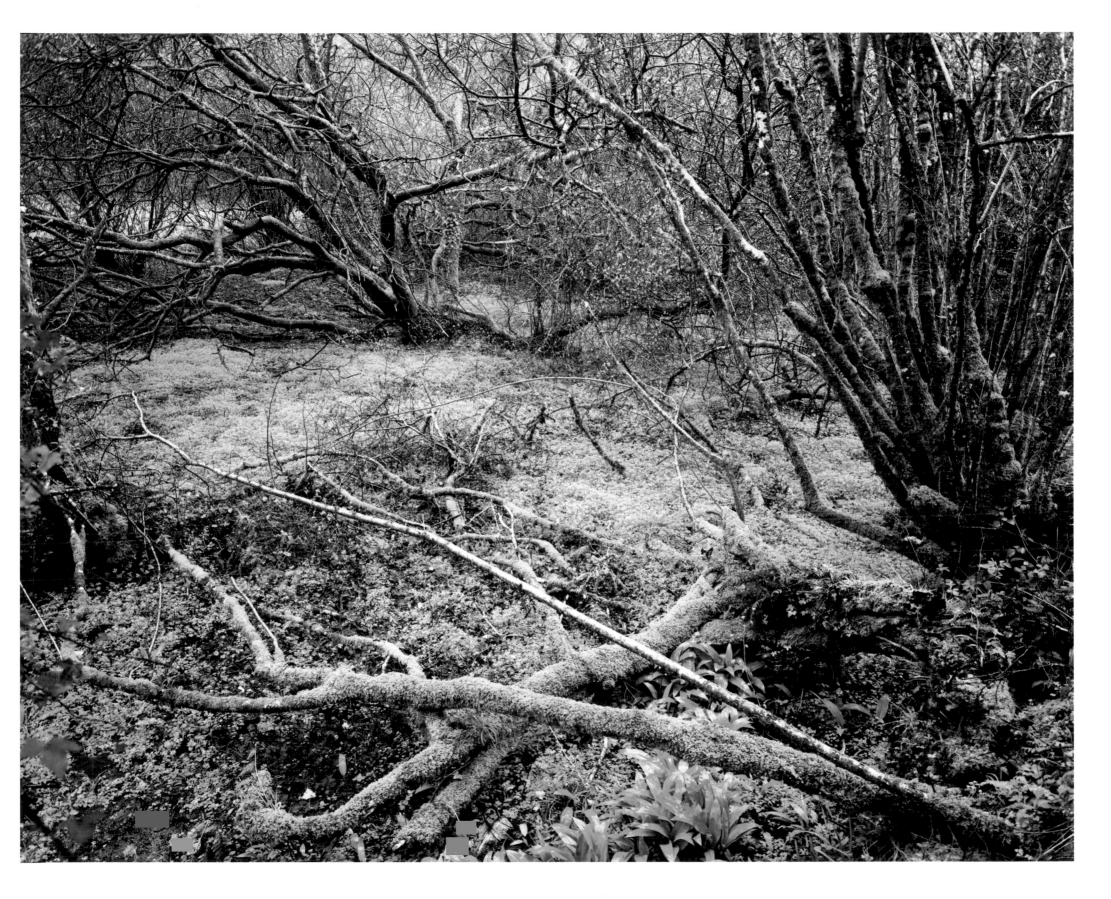

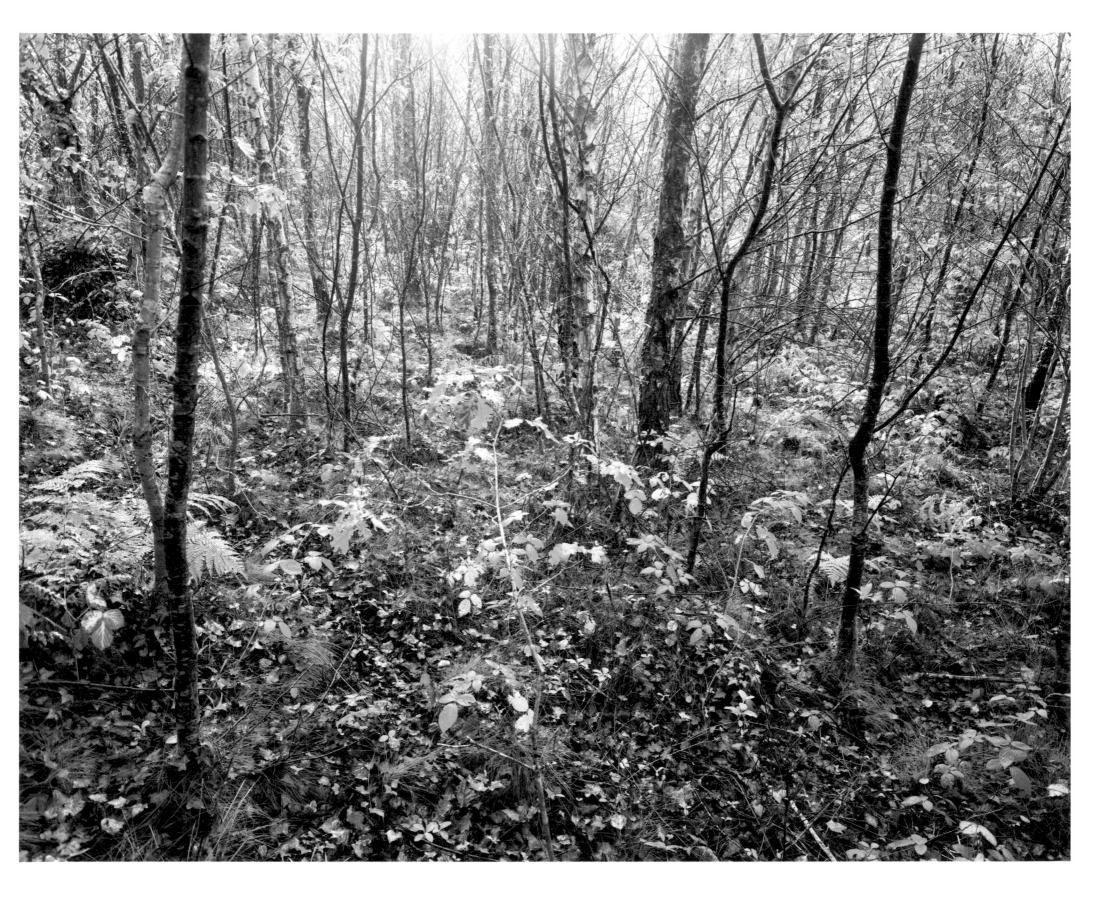

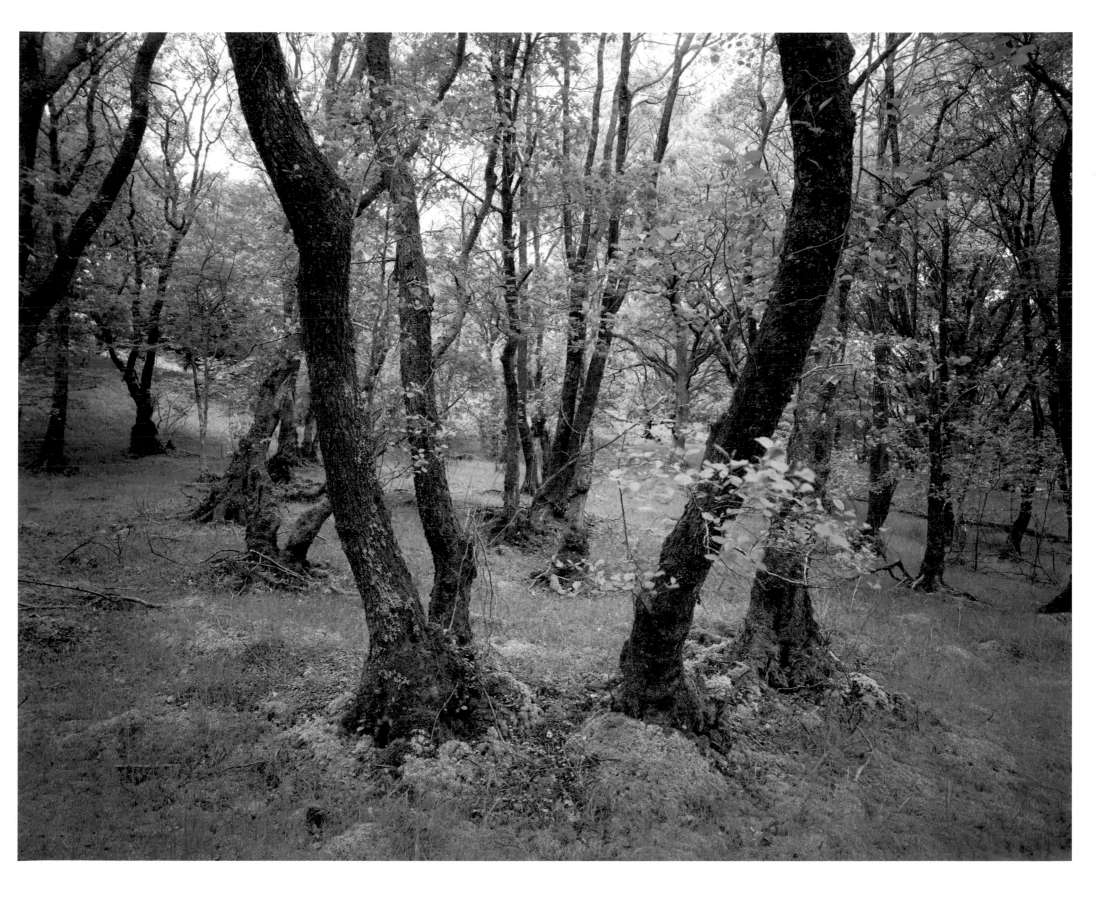

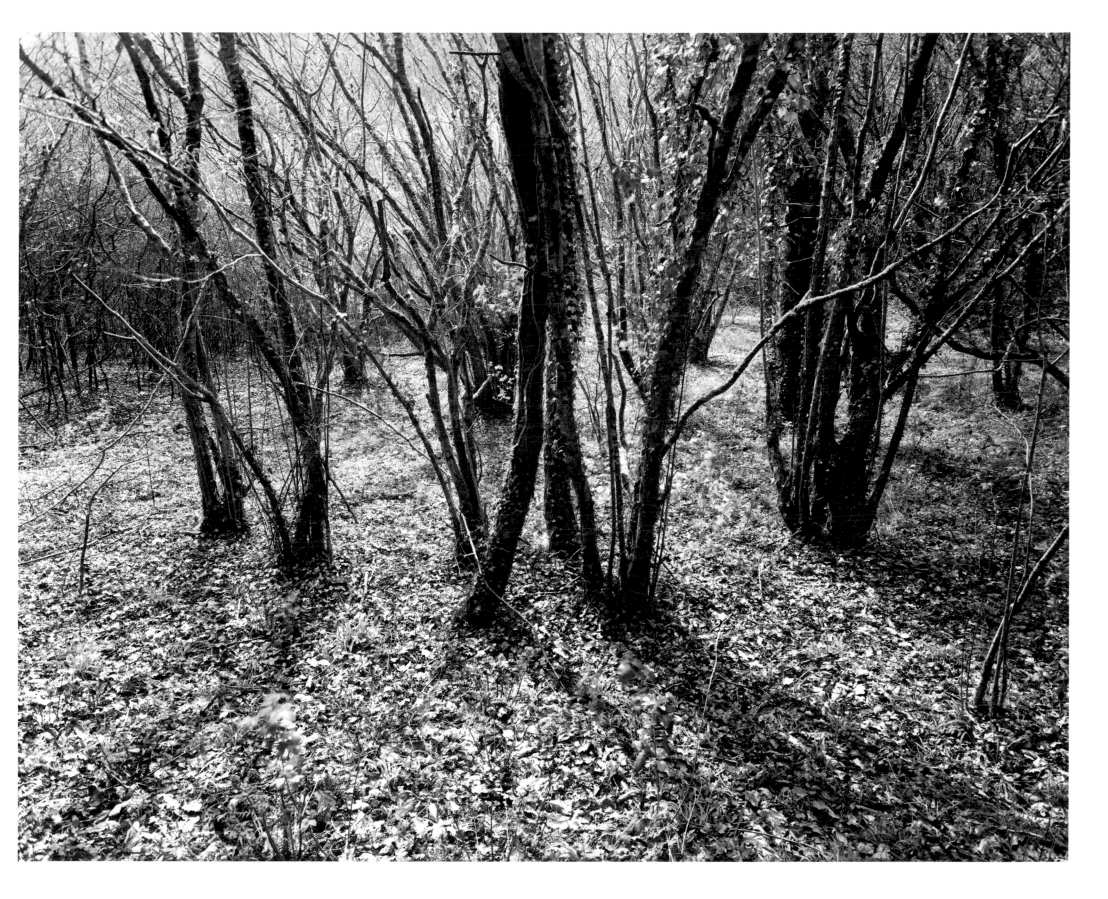

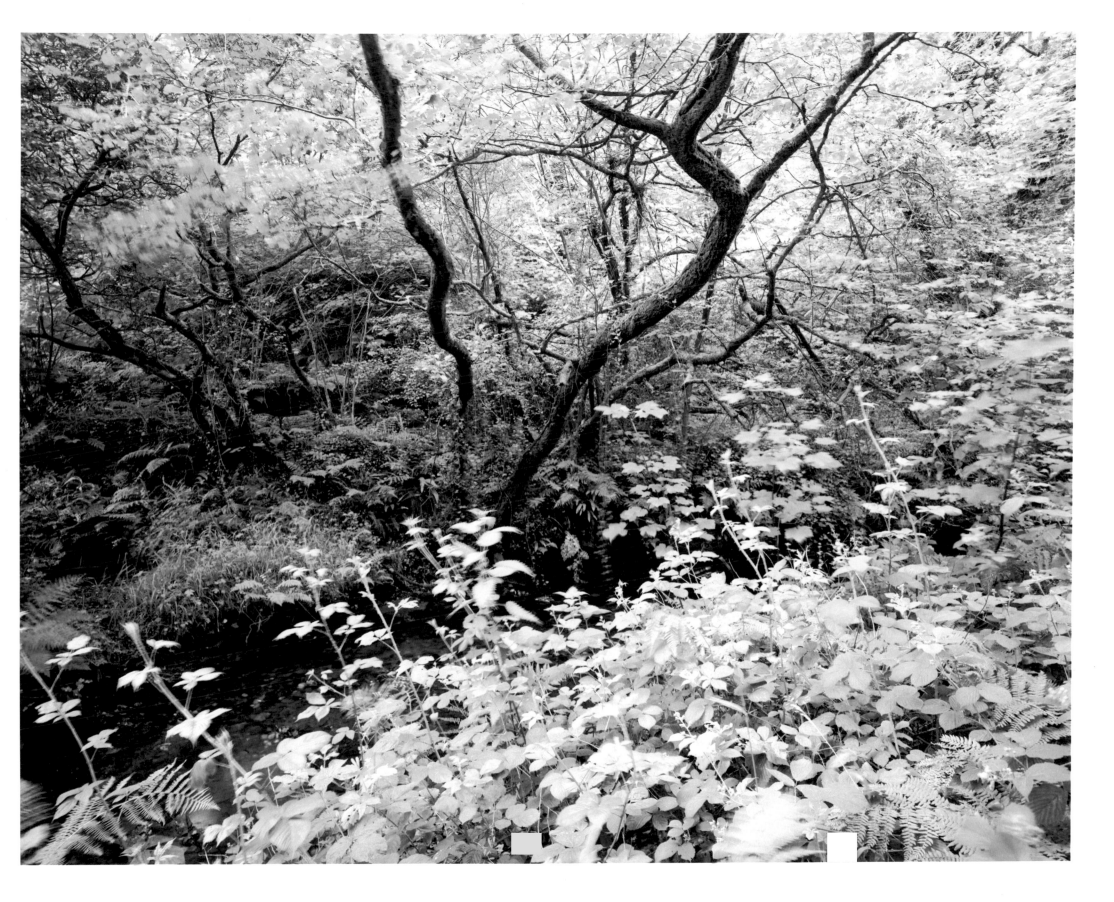

In Silva Sacra There's an old Welsh saying: three sacred things – bards, groves, kings. Not that Welsh history has been altogether free of regicide, nor that the merits of Welsh verse do not get argued over at every Eisteddfod, but forests are another matter. The Welsh forest was not the royal preserve of the English, or the Alpine realm of banditti – only picturesque from a distance – or the Germanic forest of witches and septets of dwarfs: places of darkness and mystery, harbours of legend and myth, in folklore and in literature, from Tolkien's Fangorn to, more recently, Holdstock's Ryhope wood (both of which, incidentally, are nonetheless inhabited, even by strange creatures such as ents and mythagos.) For a rural people, as the Welsh were for most of their history until the Industrial Revolution, forests were part of a shared landscape: respected, not owned, but not hostile nor alien either. Coppicing and felling meant charcoal for warmth and timber for shelter, alongside furnishing acorn for the pigs in autumn, and deer and boar for the table in season. A balanced and nuanced relationship: taking and letting be.

The Welsh respect for forests was not just good husbandry: long before the arrival of Christianity, Druidic rituals were linked to the forest, and clearings in forests played a special role for chivalric encounters in the Mabinogion, that first work of Welsh literature. The early Church integrated symbolism from the forest into its decoration and ritual. The presence of the forest was both material and spiritual, a continuation of the Arthurian tradition of the Grail (again a Christian appropriation of Celtic myth), which, in the filmmaker John Boorman's words, 'speaks to us of a period in which nature was unsullied and man in harmony with it'.

Pete Davis is a Welsh photographer for whom such managed forests have become a major subject in recent years. These surviving forests are palimpsests of their own history, telling not just of the arboreal realm but also the human intervention in their landscapes, changing with the seasons and with time. Once in use but now 'left to nature', these sites are witnesses to generations of human activity, and the transformations that result from change in that activity can still be read in them. At the same time, this body of work explores the dichotomy between the reality of managed forests and their rich overlay of legend, folklore and myth.

How then to photograph a forest? The short answer is 'with difficulty'. A large-format (10" × 8") field camera, its tripod and lenses and a box of five double plates weigh a fair bit, and the sites Pete chooses are not necessarily easily accessible. This is not just gymnastics: effectively, the materiel used imposes certain constraints on the photographer, or, more exactly, the constraints are chosen as part of the method of working. Other photographers, Pete points out, might reconnoitre the site with a Polaroid or 35 mm camera, garnering images from which

to make a selection before the definitive shoot. On practical grounds, the subject matter makes this approach difficult: the light in the forest changes all the time, wind affects the movement of leaves and branches, rainfall creates momentary reflections. The moment on 35 mm film may not recur the next time. But beyond practicality lies a philosophical approach that sees the photographic process as a meditation on a subject, not an instantaneous response. Giving the nuances of the space under consideration time to settle and be absorbed, considering different angles and approaches and distances to the subject, mindful that the box of plates represents a potential ten, and only ten, images for a day's work. This positive choice, seemingly restrictive, forces concentration and thought. Nor is it that easy to move a field camera around: 'It's more a matter of choosing a position with my head than moving the camera around', Pete explains. Add to this that the final composition and focussing is done under a hood, guided by the inverted image on the ground-glass screen of the camera, and it becomes clear that the process is both constructed and aleatory. Constructed, not just in the sense of planning and formulating each carefully chosen image, but also through a ritual after each image is taken. Pete gets back under the hood and from the ground glass makes a small sketch of the image in his notebook, together with, as often as not, a comment. This began as a means of recording images but has since become part of the structure of the photographic process. The notes and sketches are private; they are not intended as part of the final work. As Pete jokes, 'Sometimes the note will simply be that I'm fed up with the rain and longing for a pint of bitter'. This is disingenuous: the notes and sketches are a means of reinforcing concentration, of engaging more closely with the forest both as topos and topic.

What then to photograph in a forest or of a forest? Here, too, the answer is not easy. The facile solution would be great gnarled trunks, thrusting branches against the sky, serried ranks of trees lined to mark the forest boundary. However, such images would be detail at best, or at least foreground only, not the intimacy of reality. But what is this reality? For Pete this is about the forgotten, overlooked and peripheral spaces. Why these? Partly because the grand axes and great views obscure the realities of change, overwhelm the minutiae of indicators. Partly because change is micro, not mega, and grand views obliterate the subject of change. But overall because it is in the intimate view that the reality can be observed. Why should this be so? The individual tree does not, of course, stand for the forest, nor does – more importantly – the wider view. What is needed is depth of detail and contrasts of detail. Not glaring contrasts but subtle ones, which is what the overlooked delivers. There is thus this paradox that the managed history is best discernable in the contemporary neglected.

Best discernable – perhaps only discernable – with a large-format camera, used close to the subject. The exhibition size of the resulting prints is 2 × 3 m, inviting the viewer to enter into the scene, looking for the significant detail, re-enacting the process of the photographer. Thus the visitor is involved in the same *ralentissement* of the gaze that produced the original image. All photographs, it could be argued, deserve slow scrutiny. Here the praxis of the photographer and the content of the image demand it.

This body of work represents a major development in Pete Davis's oeuvre in that it is the first set of works he has executed in colour. 'I had used colour in commercial work before', Pete admits, 'but all my creative work had been in black and white. The first images I took in Tyr Canol would have worked just as well in black and white; they were composed in a Modernist manner, complete within the frame. But they looked too Tolkienesque: they didn't fit the brief I had set myself, to reveal the history and potential of forest as a central motif. What I needed to do was to free myself up so that the images could hint at what was beyond the frame, even behind the viewer.' Colour – much to the surprise of those who knew Pete's work – was the right solution and one he found wholly appropriate.

These images do not document the history or archaeology of forests, nor the animal activity, nor again the changes of the seasons (though in some cases – again unusually in this work – certain sites were revisited); rather, they seek to establish the vocabulary of potential embodied in a limited and even nondescript geographical space. The images, through their density and complexity, invite the viewer to construct an independent narrative for the space: Why is it as it is? How has it come to be as it is? What does that exploration tell us about wider things? This is what all images should do, but few achieve.

The inspiration for this work came from a project in Sardinia seven or eight years before, where Pete realised that images of the managed woodlands there in themselves offered a way of understanding the way of life and values of the local farmers and their community. Projecting this contemporary notion onto the almost millennial substrate of forests such as Pen Gelli was an ambitious task, but one which Pete has accomplished with images of sonorous depth and beauty. It has been a longer process than he imagined, but the invitation to photograph for a season in Vermont and the later association with the University of Lampeter's archaeological work at Strata Florida provided the necessary further depth to the venture for it to succeed.

One traditional view of the forest is as a dramatic environment, the fateful arena for Hansel and Gretel, the multitiered mythago-ridden Rydhope.

Another is the comic amphitheatre of Shakespeare's *Midsummer Night's Dream,* a realm where faery and human intermingle. A third – and more modern view – is the forest as an ecological home, documenting a vision of the potential of the future. There are of course others but each is, as the first three, selective, choosing an aspect of the forest, not its totality.

What Pete Davis has achieved is both to synthesise these different views and move beyond them to tell us something of the locus classicus of the forest. What is revealed is not Dante's *selva oscura* but a complex and vibrant environment in which a careful eye can read, with time, the patterns of nature and nurture, and the complexities of light and shade. This is not forest as drama or tragedy (where are the Aristotelian unities after all?) nor forest as myth. What comes to us here is the forest as epic, engaged on its own Odyssey.

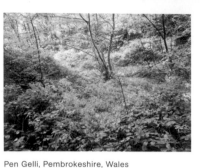

Pen Gelli, Pembrokeshire, Wales

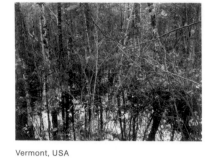

Vermont, USA

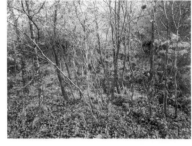

Pen Gelli, Pembrokeshire, Wales

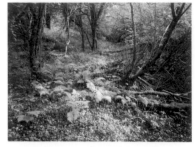

Pen Gelli, Pembrokeshire, Wales

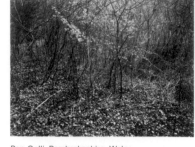

Pen Gelli, Pembrokeshire, Wales

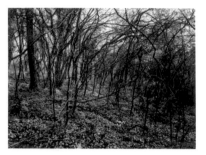

Pen Gelli, Pembrokeshire, Wales

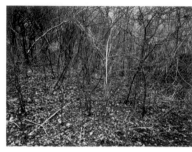

Pen Gelli, Pembrokeshire, Wales

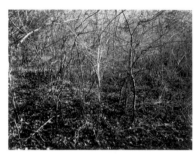

Pen Gelli, Pembrokeshire, Wales

Pen Gelli, Pembrokeshire, Wales

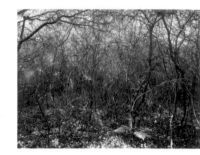

Pen Gelli, Pembrokeshire, Wales

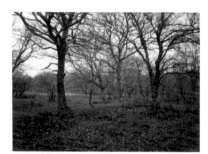

Strata Florida, Ceredigion, Wales

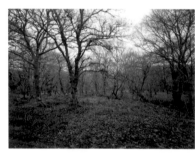

Strata Florida, Ceredigion, Wales

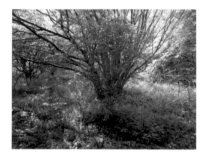

Pen Gelli, Pembrokeshire, Wales

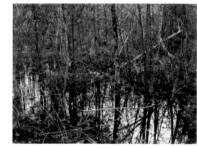

Vermont, USA

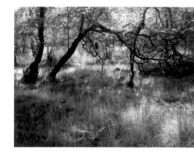

Strata Florida, Ceredigion, Wales

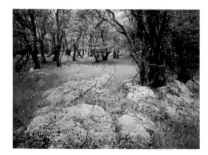

Strata Florida, Ceredigion, Wales

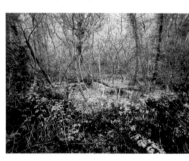

Pen Gelli, Pembrokeshire, Wales

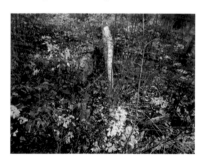

Vermont, USA

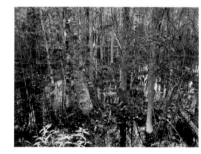

Vermont, USA

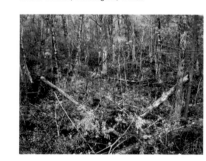

Vermont, USA

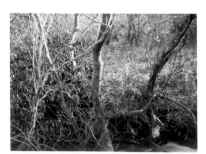

Strata Florida, Ceredigion, Wales

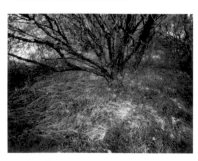

Pen Gelli, Pembrokeshire, Wales

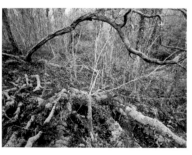

Pen Gelli, Pembrokeshire, Wales

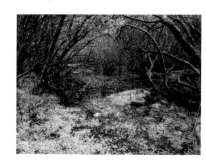

Pen Gelli, Pembrokeshire, Wales

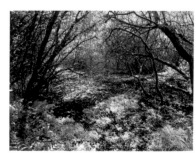

Pen Gelli, Pembrokeshire, Wales

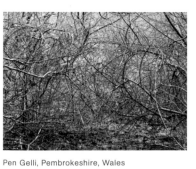

Pen Gelli, Pembrokeshire, Wales

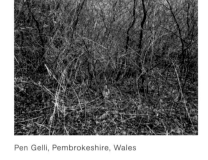

Pen Gelli, Pembrokeshire, Wales

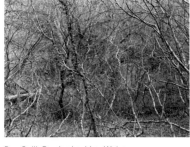

Pen Gelli, Pembrokeshire, Wales

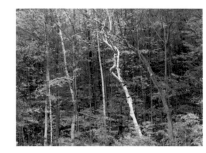

Vermont, USA

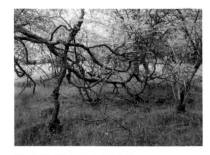

Strata Florida, Ceredigion, Wales

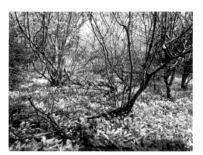

Pen Gelli, Pembrokeshire, Wales

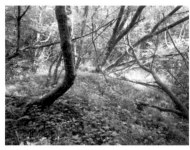

Pen Gelli, Pembrokeshire, Wales

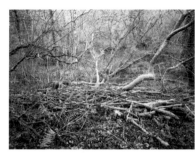

Pen Gelli, Pembrokeshire, Wales

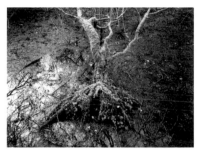

Pen Gelli, Pembrokeshire, Wales

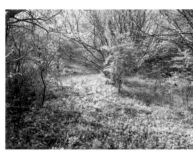

Pen Gelli, Pembrokeshire, Wales

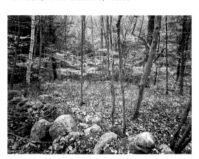

Vermont, USA

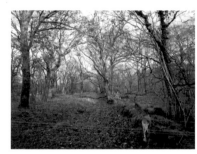

Strata Florida, Ceredigion, Wales

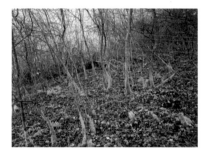

Pen Gelli, Pembrokeshire, Wales

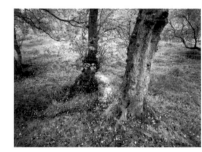

Strata Florida, Ceredigion, Wales

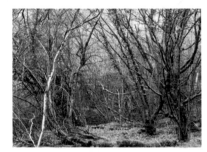

Pen Gelli, Pembrokeshire, Wales

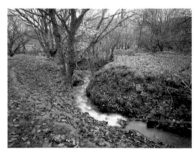

Strata Florida, Ceredigion, Wales

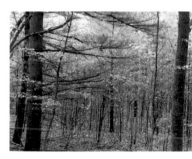

Vermont, USA

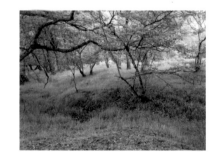

Strata Florida, Ceredigion, Wales

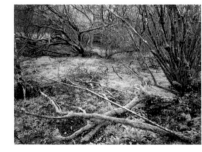

Pen Gelli, Pembrokeshire, Wales

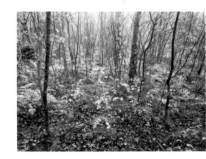

Pen Gelli, Pembrokeshire, Wales

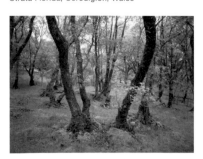

Strata Florida, Ceredigion, Wales

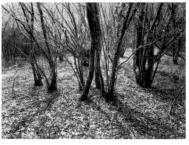

Pen Gelli, Pembrokeshire, Wales

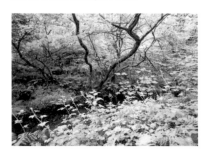

Pen Gelli, Pembrokeshire, Wales

In Wildwood
Pete Davis

Lithography: Sturm AG, Muttenz
Printing: Konkordia GmbH, Bühl
Binding: Josef Spinner Großbuchbinderei GmbH, Ottersweier
Concept: Pete Davis
Design: Integral Lars Müller
Production: Marion Plassmann

Lars Müller Publishers
5400 Baden/Switzerland
www.lars-muller-publishers.com

www.pete-davis-photography.com

ISBN: 978-3-03778-142-5

Printed in Germany

Published with the support of

CEFNOGI CREADIGRWYDD
CYNGOR CELFYDDYDAU CYMRU
THE ARTS COUNCIL OF WALES
SUPPORTING CREATIVITY

Canolfan y Celfyddydau
Aberystwyth
Arts Centre

University
of Wales,
Newport
Newport School
of Art, Media and
Design

Prifysgol
Cymru,
Casnewydd
Ysgol Gelf,
y Cyfryngau a
Dylunio Casnewydd